LEONARDO IN DETAIL

Leonardo

in Detail

Stefano Zuffi

The Portable Series

■LUDION

Contents

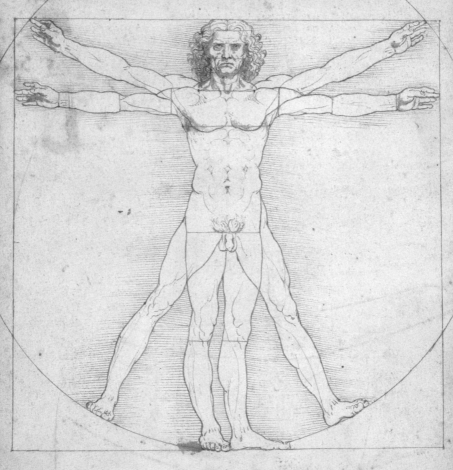

Introduction

Leonardo da Vinci. A genius. *The* genius, even: the universal man, a mind capable of anything, a philosopher of nature, an inimitable painter, a scientist of the cosmos, explorer of the human body, inventor of technology, intellectual visionary, ruthless creator of frighteningly destructive war machines, hydraulic engineer, scenic designer for festivals and so much – too much – more.

We might as well admit it: Leonardo makes us uneasy. With the stern gaze of his famous self-portrait, he appears almost to transcend the human horizon. His creativity, which stretched to the limits of the imaginable, the scope and depth of his technical and scientific interests, his uncongenial relations with his artist colleagues, his vanguard projects, the mysterious fascination of his not numerous but always extraordinary paintings, the sublime and fragile beauty of the drawings, and even his left-handed handwriting, which guarded the secret of the codices, all combine to create a sort of distance, a space in which fantastic myths, legends, romances and hypotheses can develop.

Nonetheless, we might attempt to revise this point of view. If we reread his life with a disenchanted eye, Leonardo no longer appears to be an infallible genius but by turns a difficult, restless boy, a man fraught with failings who went through a succession of bankruptcies, and, in the end, a stubborn, solitary old man. None of the many treatises he sketched out ever assumed a publishable form – they remained a confused mass of notes (the so-called *Treatise on Painting* is a posthumous collection put together by his pupils). Very few paintings were executed in a final and coherent manner. His

experiments in developing a wall-painting technique alternative to classical fresco proved disastrous. The famous 'machines' described and sketched in the codices very often do not work in reality. The attempts to devise ways for man to fly had catastrophic results. And we can only wonder why a man so open to research into the geography of the Earth and observing the Moon never referred to the discoveries of his time: not even a nod to the world beyond the sea that would be named for Amerigo Vespucci, a member of a Florentine family Leonardo knew well. His reluctance to finish anything and his perennial dissatisfaction were well known to his contemporaries – as the architect and treatise writer Sebastiano Serlio recalled in 1545: 'The most capable Leonardo Vinci was never happy with what he did and brought very few works to perfection. He often said the cause was that his hand could not attain the level of his intellect.'

From this perspective, Leonardo can seem a little less unapproachable. Perhaps his true greatness lies in his placing no limit on the possibilities of knowing the world, which he represented in painting without letting himself be conditioned by preconceptions or religious dogma. He himself admitted to having received practical and technical training without acquiring any solid cultural depth and without mastering Latin, indispensable for direct access to many texts. In compensation, he developed an exceptional ability to observe the world directly – every phenomenon of nature and reality. Leonardo sought unfiltered knowledge, verified empirically by himself, and did not take refuge behind the indisputable authority of classical texts: 'It seems to me that sciences,

which are not born of experience – the mother of all certainty – are vain and full of errors and do not end in known experience. That is, their origin, or means or ends, do not pass through any of the five senses' – a proud and peremptory assertion that in the end redeems the inferiority complex underlying the admission that he was an 'unlettered man'.

This somewhat awkward offspring from the extramarital affair of a well-respected provincial notary received training in the crafts, not classical culture. His style is rooted in the atmosphere of Florence in the second half of the fifteenth century and the practices of the artists' workshops of that period. The flourishing studio of Andrea del Verrocchio was a prestigious factory that produced not only paintings and sculptures of widely disparate dimensions and in a multiplicity of materials, but also furniture, scenery, luxury objects, coats of arms, ephemeral decorations for festivals and various other decorations, not to mention accomplishing the technical feat of mounting a bronze sphere on the pinnacle of the dome of Florence Cathedral.

Until the age of thirty, Leonardo lived in the humanist atmosphere of Medici Florence alongside contemporaries and fellow students such as Botticelli and Perugino. Stubbornly resistant to common traditional artistic practices, the young Leonardo did not shy from direct, even polemical, confrontation with other Florentine masters. His desire to go beyond elegance of line and compositional balance soon became evident: from his first works, Leonardo strove to instil painting with atmospheric phenomena, 'movements of the soul', observations from nature, the concept of dynamic action continually in the process of becoming.

Then came an existential turning point that opened this gifted young painter's mind to a universal dimension. In 1482, while friends and colleagues such as Botticelli, Ghirlandaio, Perugino and Signorelli were busy painting frescos on the walls of the Sistine Chapel in Rome, Leonardo sent his résumé to Ludovico Sforza (called 'il Moro'), the ambitious duke of Milan. In precise legal and bureaucratic language, Leonardo outlined his professional qualifications in ten points. The first nine were devoted to engineering and military, hydraulic and civil technology. Only in the tenth did Leonardo state that 'in times of peace' he could 'give perfect satisfaction' in architecture, sculpture and painting, and could bear comparison with any other artist, 'whomever you wish'. Summoned by the duke and his services immediately called upon in various sectors, Leonardo spent a great part of his career – almost a quarter of a century – in Lombardy. Milan and the landscape of Lombardy became his great 'laboratory': besides acquiring both economic stability and prestigious responsibilities, Leonardo had the opportunity to meet stimulating personalities in a lively cultural milieu, to circulate in an evolving, multifaceted environment, and discover books and up-to-date means of deepening his scientific research. 'A painter is not praiseworthy unless he is universal,' he admonished, but immediately added, 'It is easy to become universal.'

Leonardo would go on to broaden the scope of his intellectual activities immeasurably. Perhaps it was to his advantage not to be in the midst of the fiery debate over the arts that exploded in Florence during the last decade of the fifteenth century, in the abrupt shift caused by the death of Lorenzo the Magnificent in 1492 and the preaching of Fra Girolamo Savonarola. However, the inevitable foundation of all his research remained painting, also conceived as the direct verification of experiments and formulas. Aware that he possessed the gift of an exceptional hand, Leonardo exalted painting as a 'science' reserved for a privileged few.

The culmination of his activity for Duke Ludovico il Moro is *The Last Supper* in

the refectory of the church and convent of Santa Maria delle Grazie in Milan. Despite its extremely fragile state of conservation, due to the ruinous combination of technical experimentation and the adversities of its surroundings, the painting allows us to understand Leonardo's role in art history, between geometry and feeling, rigour and poetry: a leading figure in a period of change, Leonardo consolidated and completed the heritage of humanism's research in perspective, anticipating the developments of the new painting of the sixteenth century.

When Ludovico il Moro and the duchy of Milan fell to the king of France, Leonardo entered a busy new phase of his career and life. After various moves, having passed the age of fifty, he returned to his origins, to Florence. In a memorable confrontation with Michelangelo, Leonardo developed the evocative effects of sfumato: from the *Mona Lisa* to the *Virgin and Child with St Anne*, the works from this period present moving, fluid faces and landscapes of almost mystical fascination. The enormously famous Leonardo jealously preserved the enigma surrounding his painting, taking his unfinished works with him in the various moves of his final years, which saw him return to Milan, stay for a time in Rome, and finally settle in France as the guest of King Francis I.

An intriguing aspect of Leonardo's activity is that he wrote down thousands upon thousands of observations and reflections on various scientific and technical topics. After his death, these were collected and arranged as homogeneously as possible in twenty volumes of notes and drawings: the 'codices'. Leonardo, who was left-handed, usually wrote from right to left, reversing the shape of the letters as he did so. Furthermore, on two facing folios, he wrote the right page first and then the left page – the opposite of the order in which they are usually read. For Leonardo, painting was an open and clear method of exposing his thinking about life and nature, while writing was an entirely personal medium, closed in on itself. According to some scholars, Leonardo's unusual handwriting might have been due to a form of dyslexia, a disorder that would also have hindered the 'genius' par excellence from learning a language other than the dialect of his native Florence. However, Leonardo's apparently indecipherable handwriting is not especially complicated to read. Using a mirror, it is possible to make it out with little difficulty after a brief period of becoming accustomed to it.

Nonetheless, the huge quantity of Leonardo's studies across enormously diverse fields of artistic, scientific and technical knowledge is a treasure that remains substantially untapped, remaining closely bound to its creator, rather than shared or applied. The unfinished state of Leonardo's scientific and technical writings and the fact that until the nineteenth century they remained unpublished meant that they could not fulfil the fundamental requisite of being communicable to others. And yet Leonardo felt the need for discussion and debate. A century before Galileo, he occasionally included 'dialogues of the great systems' (on the Earth, the Moon, water) in his codices, setting himself in opposition to an imaginary 'adversary' who raises objections and proposes counter-hypotheses. In the flow of ideas and comparisons between different positions, Leonardo identifies the path for scientific, societal and human growth. In these eternally revised, incomplete folios, in his fragile, priceless paintings, with their sfumato atmosphere and the mysterious smiles on their ineffable faces, Leonardo invites us to overcome limits, to rise higher, to look at the work from a new point of view.

Stefano Zuffi

Biography

15 Apr. 1452	Birth of Leonardo in Anchiano, a hamlet in Vinci, on the slopes of Monte Albano in the Valdarno (valley of the Arno). He is the illegitimate son of a notary, Piero d'Antonio, and a peasant woman named Caterina.
1469	Leonardo is apprenticed in the Florentine workshop of Andrea del Verrocchio, which dealt with a wide variety of media and materials. He soon becomes a collaborator of the master, showing a particular predilection for painting but probably also working in other media.
1472	He enrols in the Florentine painters' guild.
5 Aug. 1473	Date of Leonardo's oldest known drawing, a landscape depicting the Valdarno, now in the Prints and Drawings Department of the Uffizi.
1473–6	Leonardo is still with Verrocchio (as shown by his participation in the *Baptism of Christ* altarpiece now in the Uffizi, Florence) but begins to receive commissions in his own right. In these early years, he paints the *Annunciation* (Uffizi, Florence), the *Portrait of Ginevra de' Benci* (National Gallery of Art, Washington, DC) and the *Madonna of the Carnation* (Alte Pinakothek, Munich).
9 Apr. 1476	An anonymous accusation implicates the twenty-four-year-old Leonardo in a sodomy case. Among those involved is a member of the powerful Tornabuoni family. About two months later, the charges are dropped.
29 Dec. 1479	Leonardo makes a drawing depicting the hanging of Bernardo Baroncelli, one of the perpetrators of the Pazzi conspiracy, in which Giuliano de' Medici was killed.
1480–1	While other Florentine painters of his generation were called to Rome to paint the walls of the Sistine Chapel, Leonardo stayed in Florence and began to paint the *Adoration of the Magi* for the monks of St Donato a Scopeto. The work, left unfinished, is now in the Uffizi.
Summer 1482	Leonardo writes a letter presenting his qualifications to Ludovico Sforza (known as 'il Moro'), the ambitious duke of Milan. He first mentions that he has 'plans for extremely light and strong bridges, adapted to be easily portable'. Leonardo describes his professional accomplishments in ten points. Having relocated to Milan (where he arrived in the company of the musician Atalante Migliorotti), Leonardo occupies a laboratory-studio in the 'Corte Vecchia', today the Palazzo Reale, beside the cathedral. He refers to this laboratory in connection with his studies on human flight, in the codex in the Biblioteca Reale, Turin.

25 Apr. 1483	In concert with the de Predis brothers, he is commissioned to paint the central panel of a large altarpiece - the first version of the *Virgin of the Rocks*, today in the Louvre, Paris.
1487-8	He completes preliminary designs for the lantern of Milan Cathedral and undertakes other urban planning, architectural and hydraulic studies. These notes would be gathered into the so-called Codex B at the Institut de France, Paris, considered to be the oldest extant of the codices.
1489	Leonardo begins to collect drawings and notes for a treatise on human anatomy, today mostly in the Royal Collection at Windsor. The range of his scientific and technological interests broadens, but he continues to consider himself foremost a painter.
13 Jan. 1490	For the wedding of Gian Galeazzo Sforza and Isabella of Aragon, at the court of Ludovico il Moro, he prepares the 'Feast of Paradise' in the Castello Sforzesco (Sforza Castle) - a theatrical spectacle memorable for its use of awe-inspiring stage machinery.
23 Apr. 1490	Leonardo begins work on an equestrian monument of Francesco Sforza but executes only the large model for the horse, subsequently destroyed. In 1999 the American sculptor Nina Akamu will cast two bronze copies of the horse based on Leonardo's studies. One of these casts will be given to the city of Milan and placed near the San Siro Racetrack.
1490-3	Leonardo plans alterations to the Castello Sforzesco, including a tower over 120 metres tall. In connection with the Sforza court, he paints a series of famous portraits: *Portrait of a Musician* (Pinacoteca Ambrosiana, Milan), *Lady with an Ermine* (or Cecilia Gallerani, the mistress of Ludovico il Moro) (National Museum, Kraków) and the so-called *Belle Ferronnière* (probably a portrait of another of the duke's mistresses) (Louvre, Paris). A circle of artists forms around Leonardo who draw inspiration from his style. Outstanding among the earliest are Marco d'Oggiono and Giovanni Antonio Boltraffio. A young boy enters Leonardo's life, Gian Giacomo Caprotti, nicknamed Salaì ('Little Devil'). He subsequently becomes a mid-level painter and remains with Leonardo until the artist's death in France.
2 Feb. 1494	Leonardo visits the estate of the Sforzas near Vigevano, established by the dukes as a model agricultural enterprise. In Vigevano (Ludovico Sforza's native town), he collaborates with Bramante on the design of the elegant Piazza Ducale.

1495	Leonardo carefully notes expenses for the funeral of a certain Caterina. This is possibly his mother, who would have joined him in Milan.
1495-7	Peak of the commissions from Ludovico il Moro, for whom Leonardo paints the Sala delle Asse in the Castello Sforzesco and *The Last Supper* at Santa Maria delle Grazie. He devotes himself to scientific and technological research in a wide variety of areas. A significant number of sketches, plans for machines and notes from these years are collected in the Codex Atlanticus at the Biblioteca Ambrosiana, Milan, the largest collection of Leonardo's drawings in the world.
1498	In the introduction to the treatise *De Divina Proportione*, for which Leonardo provided the solid geometry drawings, the mathematician Luca Pacioli mentions the execution of *The Last Supper*.
1499-1500	On the fall of the duchy of Milan to the invading army of the French king Francis I, Leonardo, along with Pacioli, moves to the court of Isabella Gonzaga in Mantua. A stay in Venice follows. Meanwhile, Leonardo's clay model of the horse for the monument to Francesco Sforza is destroyed by French crossbowmen, who use it for target practice in the courtyard of the Castello Sforzesco.
1501	After other travels (Rome, Tivoli), Leonardo decides to settle in Florence again.
1502	In the service of 'Prince' Cesare Borgia, he plans fortifications in Urbino, Cesena and Piombino. He also completes cartographic studies.
1503-4	Leonardo works on fortifications for the republic of Florence and initiates a survey for a canal system in the Valdarno. In the Salone dei Cinquecento of the Palazzo Vecchio, in competition with Michelangelo, he paints *The Battle of Anghiari*, which quickly deteriorates. Despite the paintings' poor reception, the two large preparatory cartoons for the *Battles* executed by Michelangelo and Leonardo, exhibited in Florence, are called *la scuola del mondo* ('the school of the world'), and are intensively copied and studied.
9 July 1504	Death of Leonardo's father, the notary Ser Piero da Vinci. Leonardo, who is illegitimate, is excluded from the will, and an ensuing legal dispute with his half-brothers is not resolved in his favour.
1505-6	Leonardo begins to compile the Codex Leicester, devoted to hydraulics and physics. It also includes notes on chemistry and the flight of birds. Meanwhile, he undertakes the meticulous elaboration of the *Mona Lisa*. In regard to the legendary smile, Giorgio Vasari recalls that 'Mona Lisa was exceedingly beautiful, and while Leonardo was painting her portrait, he took the precaution of keeping someone constantly near her to sing or play on instruments, or to jest and otherwise amuse her to the end that she might continue cheerful, and so that her face might not

exhibit the melancholy expression often imparted by painters to the likenesses they take.'

1508	Leonardo returns to Milan, taking with him his incomplete paintings including the *Mona Lisa* and the *Virgin and Child with St Anne*.
1509-10	Engaged in hydrography studies of the Po Valley, he redefines the canal system around Milan. He collects new studies on anatomy, chemistry, botany and architecture. He does not succeed in finishing the equestrian monument to Gian Giacomo Trivulzio, marshal of France and governor of Milan.
1513-15	Leonardo leaves Milan for Rome. A guest of Cardinal Giuliano de' Medici, he makes plans for draining the Pontine Marshes. He turns his attention to burning mirrors and other mechanical contrivances. He travels to Parma, Bologna and Florence.
1516	At the invitation of King Francis I of France, he goes to live at the Château du Clos Lucé, near Amboise.
1517	Luigi d'Aragona's secretary, Antonio de Beatis, records a meeting with Leonardo during which he sees three paintings (*Mona Lisa*, *St John the Baptist* and the *Virgin and Child with St Anne*) and some manuscripts. Leonardo is in pain and weakened by a paralysis of the right hand. However, because he is left-handed, he is able to continue working.
2 May 1519	Leonardo dies at Cloux, after completing his last painting, the *St John the Baptist* now in the Louvre. He is buried in the chapel of St Florentin, in the grounds of the Château d'Amboise. After the destruction of the chapel, the presumed remains of Leonardo will be reburied in the chapel of St Hubert, also at the Château d'Amboise. According to his will, drawn up on 23 April, all his drawings and manuscripts are left to his friend and pupil, the Milanese Francesco Melzi, who was named executor of the will. The paintings and part of a vineyard near the convent of Santa Maria delle Grazie in Milan go to Salaì.

Works

The works are reproduced in full and given
a catalogue number (referred to in the captions).

The technical data include the following elements:
– Short descriptive title, followed by the (probable) year of creation;
– Current location;
– Inventory number;
– Dimensions, height followed by width;
– Technique.

1

Madonna and Child with a Pomegranate, or the *Dreyfus Madonna, c.*1470

<small>Washington DC, National Gallery of Art, Samuel H. Kress Collection</small>

inv. 1144 (K 1850)
16.5 × 13.4 cm
Oil and tempera on poplar panel

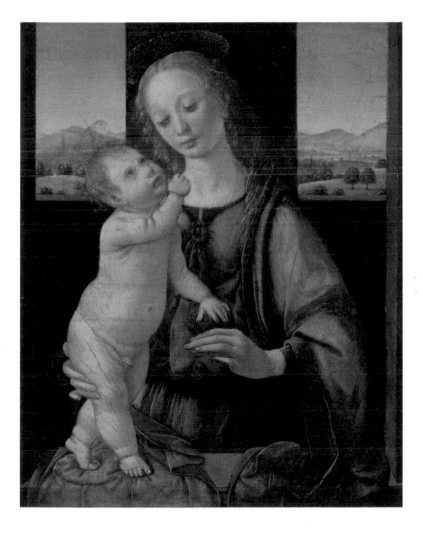

Baptism of Christ, 1470–5

INV. 8358
177 × 151 cm
Oil and tempera on poplar panel

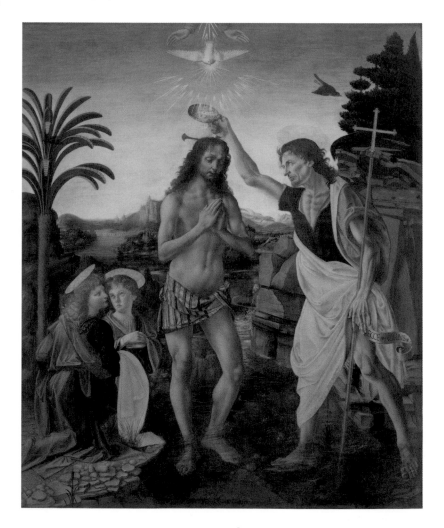

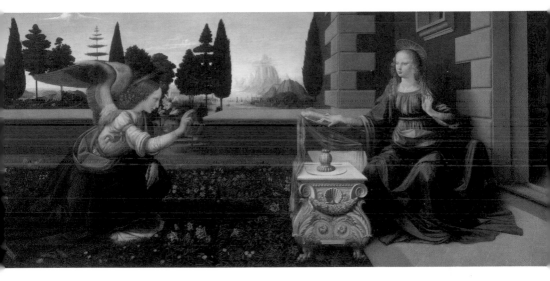

3

Annunciation, c. 1473

Florence, Galleria degli Uffizi

inv. 1618
90 × 222 cm
Oil and tempera on poplar panel

4

Portrait of Ginevra de' Benci, c. 1476–8

Washington DC, National Gallery of Art, Ailsa Mellon Bruce Fund, 1967

INV. 1967.6.1.a
38.8 × 36.7 cm
Oil and tempera on poplar panel

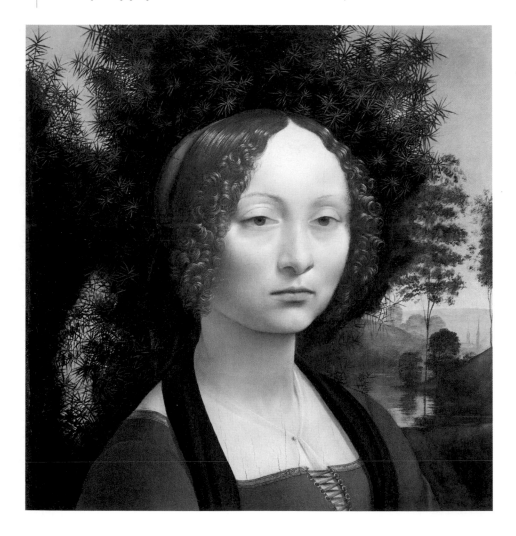

5 Inscribed scroll in a wreath of palm, laurel and juniper, reverse of the *Portrait of Ginevra de' Benci*, c. 1476–8

WASHINGTON DC, NATIONAL GALLERY OF ART, AILSA MELLON BRUCE FUND, 1967

INV. 1967.6.1.b
38.8 × 36.7 cm
Tempera (and oil?) on poplar panel

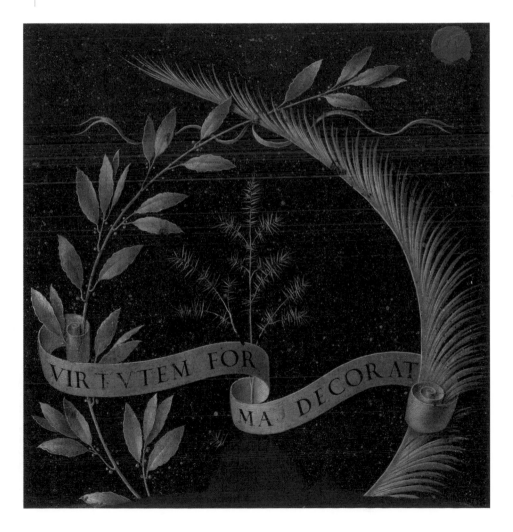

6

*Madonna of the Carnation, c.*1475

Munich, Alte Pinakothek

INV. 7779
62.3 × 48.5 cm
Tempera (?) and oil on panel

7

Annunciation, c. 1478

Paris, Musée du Louvre

inv. M.I. 598
16 × 60 cm
Tempera on poplar panel

Madonna of the Flower or *Benois Madonna*, *c.* 1480

Saint Petersburg, Hermitage Museum

INV. ГЭ-2773
49.5 × 33 cm
Oil on panel, transferred to canvas

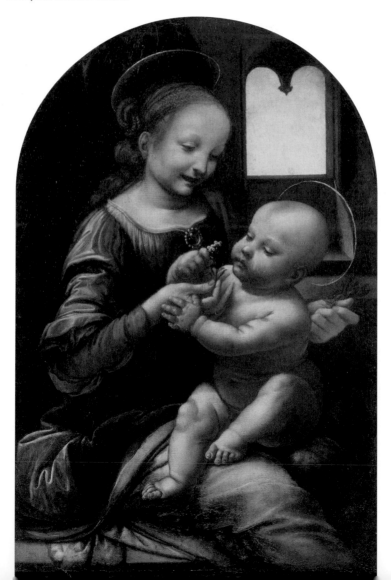

9

Adoration of the Magi, 1481–2

FLORENCE, GALLERIA DEGLI UFFIZI

INV. 1594
244 × 240 cm
Oil on panel

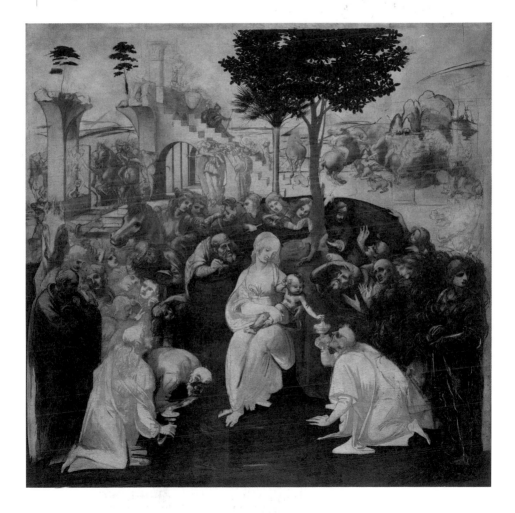

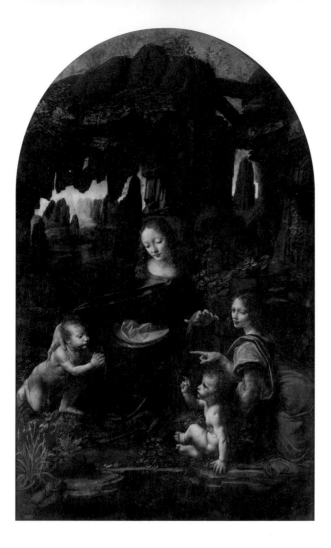

10

Virgin of the Rocks, 1483–6

Paris, Musée du Louvre

INV. 777
197.3 × 120 cm
Oil on panel, transferred to canvas

11
St Jerome, c. 1485–90
ROME, PINACOTECA VATICANA

INV. 40 337
103 × 74 cm
Oil and tempera on walnut panel

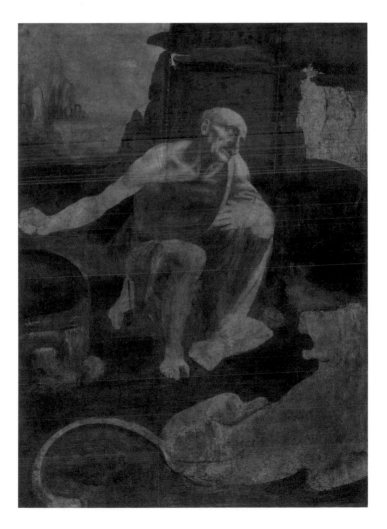

Portrait of a Musician, 1485–90

44.7 × 32 cm
Tempera and oil on (walnut?) panel

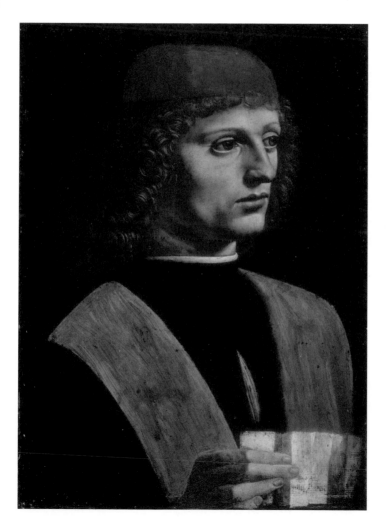

13
Lady with an Ermine, 1488–90

Kraków, Muzeum Narodowe, collection Czartoryski

INV. 134
55 × 40.5 cm
Oil on walnut panel

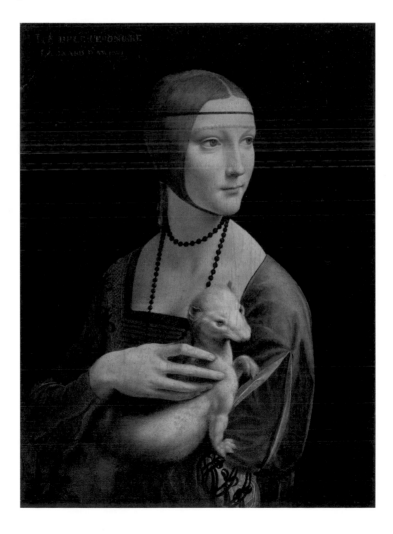

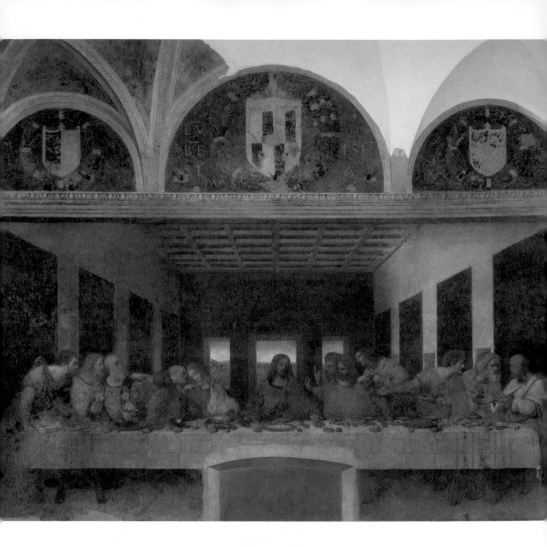

14

The Last Supper, 1494–8

Milan, Refectory of Santa Maria delle Grazie

460 × 880 cm
Tempera on two coats of plaster

15

Portrait of a Lady, called *La Belle Ferronnière*, 1495–9

PARIS, MUSÉE DU LOUVRE

INV. 778
63 × 45 cm
Oil on walnut panel

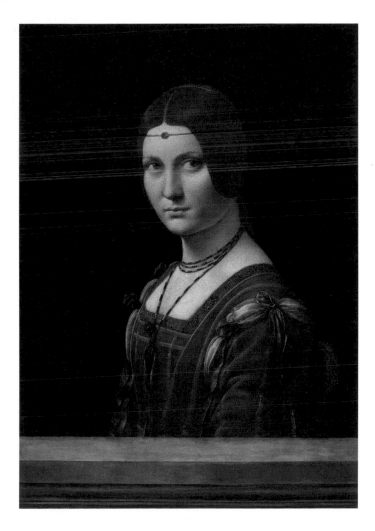

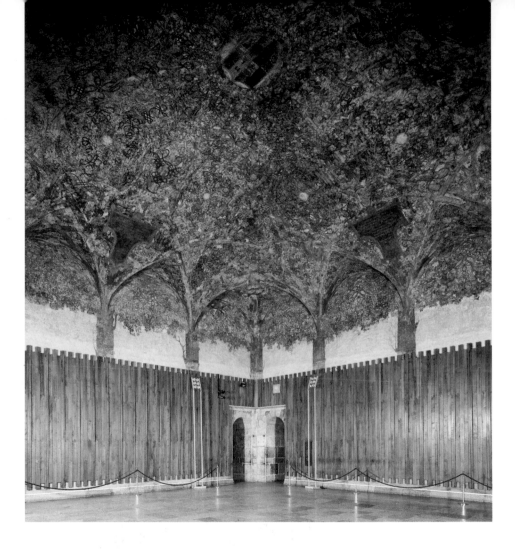

16
Sala delle Asse, 1498

Milan, Castello Sforzesco

Tempera and fresco on plaster

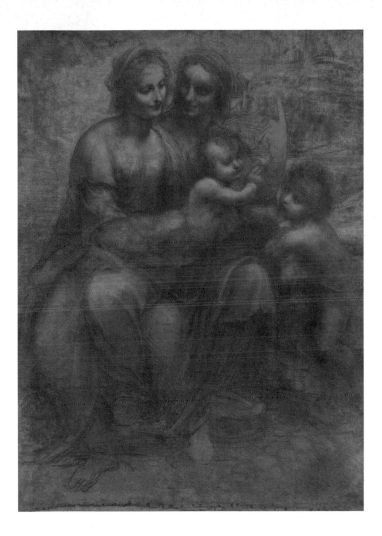

17

Virgin and Child with St Anne and St John the Baptist ('Burlington House Cartoon'), *c.* 1499–1500

London, National Gallery

INV. 6337
141.5 × 104.6 cm
Cardboard, partly heightened with white lead on brown-prepared paper, mounted on canvas

Portrait of Lisa Gherardini, called the *Mona Lisa* or *La Gioconda*, *c*. 1503–19

Paris, Musée du Louvre

INV. 779
77 × 53 cm
Oil on poplar panel

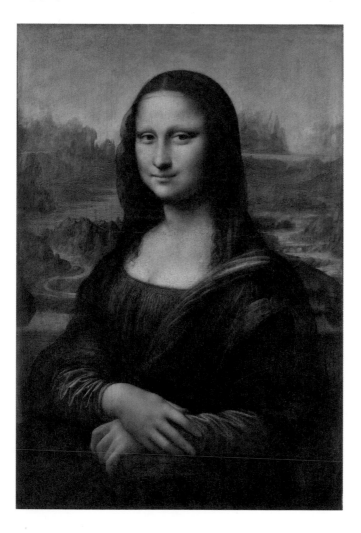

19

Virgin and Child with St Anne, c. 1503–19

Paris, Musée du Louvre

INV. 776
168.5 × 130 cm
Oil on poplar panel

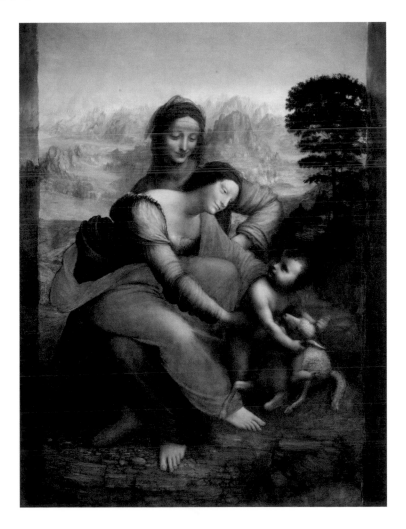

Head of a Woman, called *La Scapigliata*, 1504–8

24.7 × 21 cm
Umber and amber ochre heightened with white lead on poplar panel

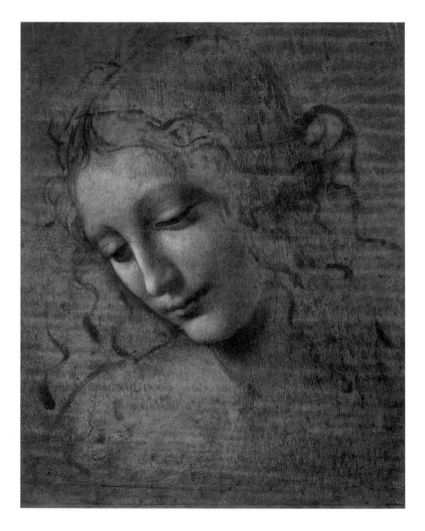

Salvator Mundi, c. 1505–9

ABU DHABI, MUSÉE DU LOUVRE ABU DHABI

65.5 × 45.1 cm
Oil on walnut panel

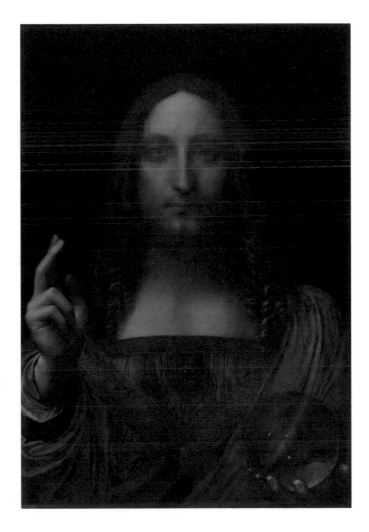

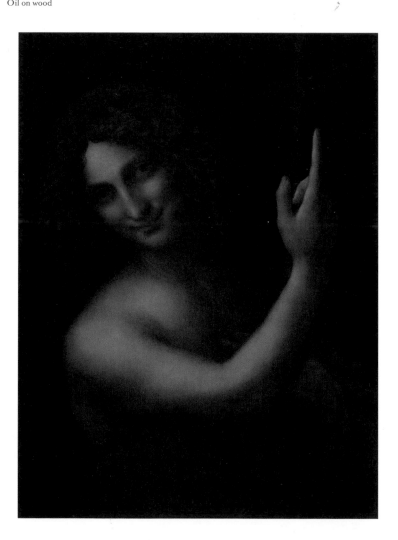

22
St John the Baptist, 1513–16

Paris, Musée du Louvre

inv. 775 (MR 318)
69 × 57 cm
Oil on wood

Drawings

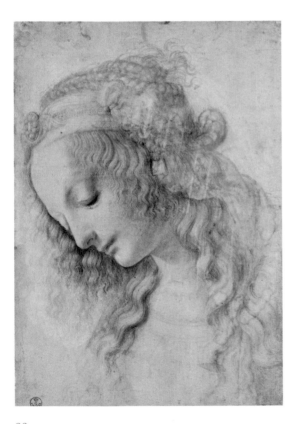

23

Study of a Woman's Face, 1468–75

PRINTS AND DRAWINGS DEPARTMENT, UFFIZI, FLORENCE

INV. 428E
281 × 199 mm
Black chalk, pen and ink on ivory-prepared paper

24

Tuscan Landscape, 5 August 1473

Prints and Drawings Department, Uffizi, Florence

INV. 8P
190 × 285 mm
Pen and ink

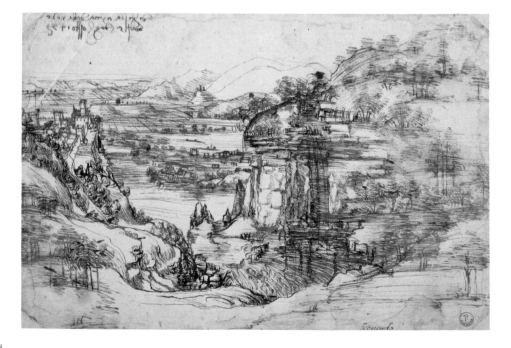

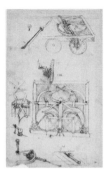

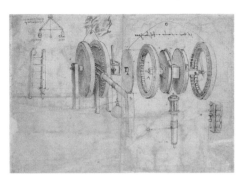

Self-propelled cart, 1478

MILAN, BIBLIOTECA AMBROSIANA

Codex Atlanticus, fol. 812r
265 × 167 mm
Pen and ink

25

Two-wheel winch, c. 1480

MILAN, BIBLIOTECA AMBROSIANA

Codex Atlanticus, fol. 30v
278 × 385 mm
Pen and ink

26

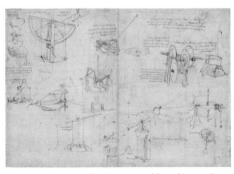

Figures and systems for flotation and breathing under water, c. 1482

MILAN, BIBLIOTECA AMBROSIANA

Codex Atlanticus, fol. 26r
291 × 400 mm
Pen and ink

27

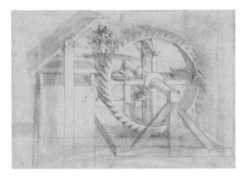

Repeat firing mechanism for a crossbow, c. 1482

MILAN, BIBLIOTECA AMBROSIANA

Codex Atlanticus, fol. 1070r
182 × 250 mm
Pen and ink

28

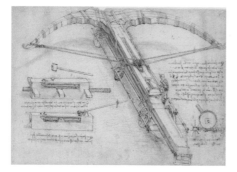

Giant crossbow, c. 1482

MILAN, BIBLIOTECA AMBROSIANA

Codex Atlanticus, fol. 149b/r
203 × 275 mm
Pen and ink

29

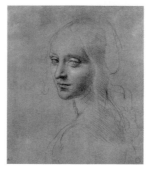

Head of a Young Woman, c. 1483

TURIN, BIBLIOTECA REALE

INV. 15572 d.c. recto
182 × 159 mm
Silver point on brown-prepared paper

30

Mortars with exploding projectiles, 1485

MILAN, BIBLIOTECA AMBROSIANA

Codex Atlanticus, fol. 33r
218 × 410 mm
Pen, ink and pencil

31

Study of swing bridges, 1485–90

MILAN, BIBLIOTECA AMBROSIANA

Codex Atlanticus, fol. 855r
250 × 206 mm
Pen and ink

32

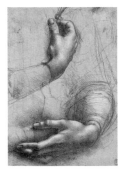

Study of a Woman's Hands, 1486–8

WINDSOR, ROYAL LIBRARY

INV. RL 12558 recto
215 × 150 mm
Metal point on red-prepared paper

33

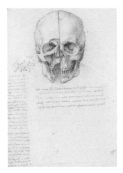

*Anatomical study of a skull, sagittal section,
front view,* 1489

WINDSOR, ROYAL LIBRARY

INV. RL 19058 verso
183 × 130 mm
Pen and brown ink

34

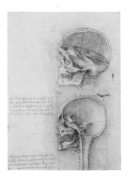

*Anatomical studies of a human skull, sagittal section,
side view,* 1489

WINDSOR, ROYAL LIBRARY

INV. RL 19057 recto
188 × 134 mm
Pen, brown ink and two shades of charcoal

35

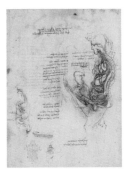

Diagram of copulation, lateral section, c. 1490

WINDSOR, ROYAL LIBRARY

INV. RL 19097 verso
276 × 204 mm
Pen and brown ink

36

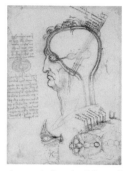

Anatomical study of the cerebral lobes and the scalp, 1490–3

Windsor, Royal Library

inv. RL 12603 recto
203 × 152 mm
Pen, two shades of ink and red chalk

37

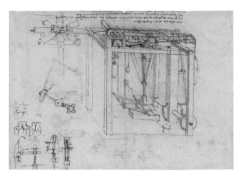

*Gold-beating machine, c.*1493

Milan, Biblioteca Ambrosiana

Codex Atlanticus, fol. 29r
290 × 393 mm
Pen, ink and pencil

38

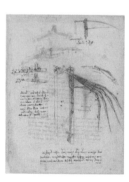

Mechanical wing, 1494

Milan, Biblioteca Ambrosiana

Codex Atlanticus, fol. 844r
290 × 218 mm
Pen and ink

39

*Geometry exercises, c.*1496

Milan, Biblioteca Ambrosiana

Codex Atlanticus, fol. 455r
289 × 434 mm
Pen and brown ink

40

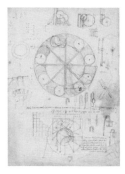

Perpetual-motion machine, c. 1496

41

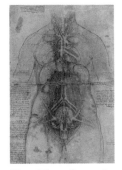

View of the cardiovascular system and a woman's mammary and abdominal organs, c. 1508

42

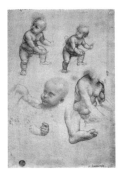

Physiological presentation of the brain, c. 1508

43

Study of a Child, c. 1508

44

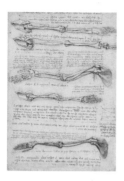

Anatomical studies of the rotation of the arm, 1509–10

WINDSOR, ROYAL LIBRARY

INV. RL 19000 verso
293 × 201 mm
Pen and ink

45

Anatomical studies of the muscles of the shoulder blade and of the mechanics of the stabilization of the joints of the clavicle, 1509–10

WINDSOR, ROYAL LIBRARY

INV. RL 19003 recto
292 × 198 mm
Pen and ink

46

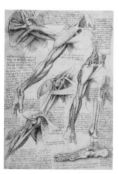

Anatomical studies of the musculature of the arm and shoulder, 1509–10

WINDSOR, ROYAL LIBRARY

INV. RL 19013 verso
289 × 201 mm
Pen and ink

47

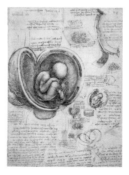

Anatomical study of a foetus in the womb, 1510–12

WINDSOR, ROYAL LIBRARY

INV. RL 19102 recto
304 × 220 mm
Pen and ink

48

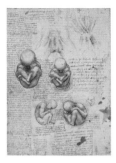

Studies of the foetus in the womb and of the dimensions and structure of the female reproductive organs, c. 1510

49

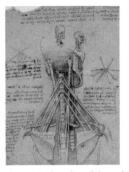

Anatomical studies of the neck and shoulder muscles, 1513–16

50

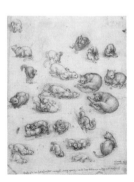

Cats, Lions and a Dragon, c. 1513–18

51

Animals

LEONARDO WAS A VEGETARIAN. According to his contemporaries, he could not bear the thought of his body serving as the 'tomb' of another living creature and he felt an instinctive revulsion at the sight of blood. Yet, he must have been tolerant of the dietary habits of the people who lived with him, given that eggs and meat appear in the shopping lists jotted in the margins of the codices.

Leonardo lived in the large cities of his time – Florence, Milan, Rome, Venice – but never hid the fact that he preferred the countryside and forests of his childhood in the hills of Tuscany. Sigmund Freud formulated a psychoanalytic theory based on Leonardo's childhood memory of being attacked by a raptor, although the father of psychoanalysis made an error regarding the exact identification of the bird based on a mistranslation of *nibbio* (kite) as 'vulture' (*Geier* in German), which would be *avvoltoio* in Italian.

Given his unconditional love of nature, which was for him an endless source of marvels that mingled 'fear and desire', Leonardo could not help but love animals. According to Vasari, when passing through the market, he bought birds for the sole purpose of freeing them from their cages and letting them fly away. Leonardo's codices include dozens of anecdotes about animals of all kinds, from docile farm animals to exotic wild beasts such as elephants, bears and crocodiles. These little stories are on the whole hastily jotted down, but some read more like the classic fables of Aesop and Phaedrus, where animals become allegories of human vices and passions. Attention to fauna is also evident in one of his most acute scientific observations: Leonardo did not consider the presence of fish fossils and shells in the mountains between Lombardy and the Veneto a simple 'joke of nature' or debris from the biblical Flood but correctly theorized the geological development of the area and the prolonged presence of water long ago: fish once swam where birds fly today!

Leonardo's drawings and paintings provide an abundant bestiary, even though they do not show the same variety and analytic curiosity the artist had about the vegetable kingdom. The most frequent animal is certainly the horse, a classic subject in humanistic culture, and Leonardo studied horses repeatedly. Birds were an indispensable source of inspiration for formulating theories about whirlwinds and the dream of endowing man with wings that would allow him, too, to fly. And, entirely contrary to the custom of his time, Leonardo seems to have liked cats better than dogs.

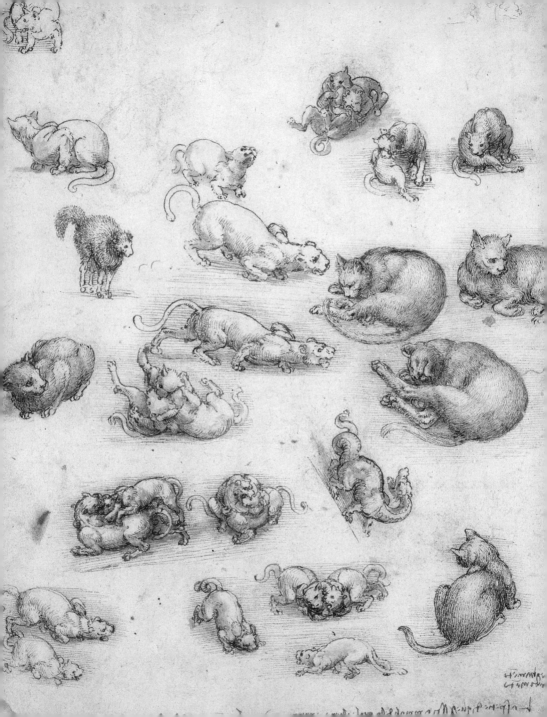

LEONARDO HAD A FONDNESS FOR CATS, being particularly taken by the lithe elegance of their unpredictable movements. He made several preliminary drawings for a 'Madonna with a Cat', though he never executed it as a painting. It was to include the Infant Jesus trying to restrain a squirming kitten. For that matter, the animal in the arms of the sitter in *Lady with an Ermine* has proportions more like those of a domestic feline than a mustelid. This sheet of drawings from Windsor Castle contains many studies of cats in various poses observed with an amused eye. There is in addition a small study of a dragon, a fantastic beast that Leonardo perhaps intended to convey the mysterious 'diabolical' vein that emerges in feline behaviour from time to time.

Cats, Lions and a Dragon (cat. 51)

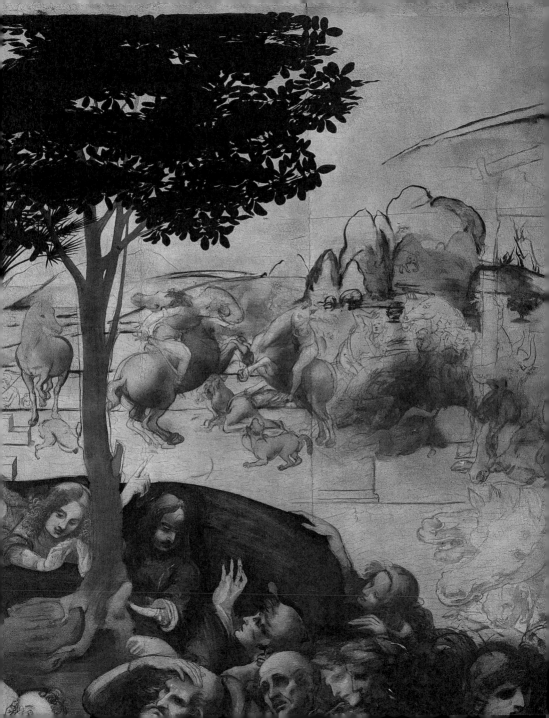

THE HORSE IS A STANDARD SUBJECT IN RENAISSANCE ART, and Leonardo was not immune to the fascination of monumental steeds, thus exposing himself to inevitable comparison with both antiquity and the masters of his own time. Precedents in the challenging feat of casting spectacular equestrian monuments in bronze were set by Donatello and then Andrea del Verrocchio, in whose workshop Leonardo trained. In his approach to horses, however, Leonardo always started from free observation of nature, capturing situations and attitudes as they occurred. The background of the *Adoration of the Magi* includes an unusual detail: barking dogs amid the hooves of shying and rearing steeds whose riders are hard pressed to maintain control. This anticipates the unrestrained fray of shouting men and jumpy horses Leonardo conceived for *The Battle of Anghiari*, prepared in Florence twenty years after the incomplete *Adoration of the Magi*.

Adoration of the Magi (cat. 9)

THE HORSES IN THE BACKGROUND of the *Adoration of the Magi* are justified by an iconographic tradition that was also firmly rooted in fifteenth-century Florence, where Leonardo received his training. In the frescos of the chapel of the Palazzo Medici in Florence, for example, Benozzo Gozzoli transformed the retinue of the Magi into a spectacular horseback procession with dozens of figures. The number of horses and the variety of their poses in the work of Leonardo, however, demonstrate a particular interest that stayed with him for much of his career. Evidence of this is his careful study of equine anatomy, documented in many drawings; his attention to the proportions and characteristics of different breeds; his project for monumental stables at the Castello Sforzesco at Vigevano; his thorough plans for equestrian monuments to Francesco Sforza, Ludovico il Moro and Gian Giacomo Trivulzio (which were never carried out), and, finally, the tangle of horsemen and foot soldiers in *The Battle of Anghiari*, which was meant to decorate the great hall of the Palazzo Vecchio in Florence.

Adoration of the Magi (cat. 9)

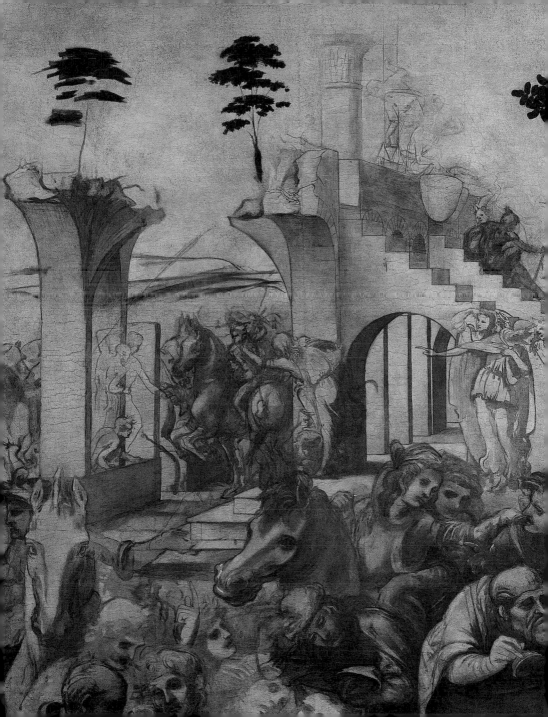

IN HIS WRITINGS ON ANIMALS, Leonardo alludes to the 'thundering roar' of the lion. The lion crouching at the feet of the penitent St Jerome raises its head, thrashes its tail nervously and opens its maw in a roar. A frequent animal in art history not only as a companion to St Jerome but also as a symbol of St Mark the Evangelist – and hence of the Republic of Venice – lions were very rarely seen in Italy, and artists generally had to make do with fantastic images or adhere to iconographic tradition. Leonardo (as Albrecht Dürer did later by visiting the archducal menagerie in Brussels) sought out the opportunity to see a real lion. Although we have no confirmation that he actually did see one, we know that the dukes of Milan owned exotic animals.

St Jerome (cat. II)

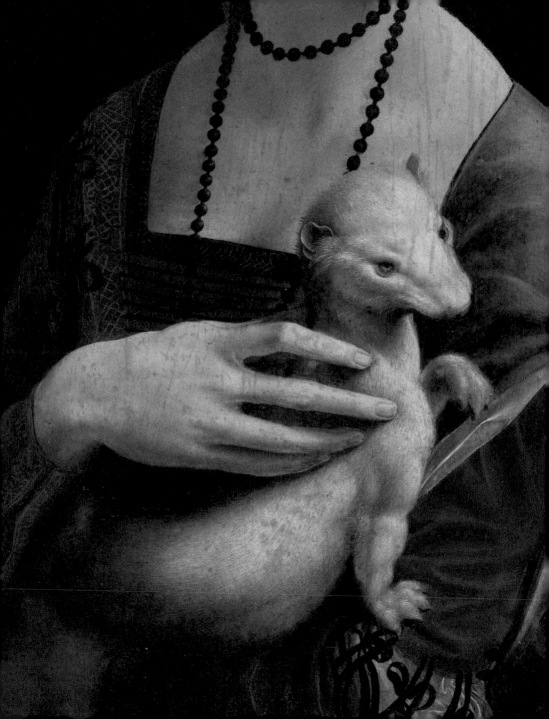

ACCORDING TO A FIRMLY ENTRENCHED TRADITION well known to
Leonardo, the noble ermine would rather be captured by hunters or
even die than allow its brilliant white coat to get dirty. Much has been
written about the appearance of the animal in the Kraków painting, its
size, tameness and snout being more suggestive of a ferret. However,
it is unquestionably an ermine, if only for the reference to the family
name of Ludovico il Moro's beautiful young mistress Cecilia Gallerani
– the Greek word for ermine is γαλή (*galé*). Leonardo gives the animal's
eyes a lively, vibrant expression, and the gentle torsion of the body and
paws creates a spiral movement that blends into the pose of the young
woman.

Lady with an Ermine (cat. 13)

In the final painted version of the *Virgin and Child with St Anne*, the Infant is playing with a lamb. He tries somewhat awkwardly to straddle the gentle, perplexed animal while pulling at its ear. The poses of the Infant and the lamb (a traditional Christian symbol of the Redeemer's sacrifice for the salvation of mankind) appear to be a fresh and spontaneous part of the composition, but they are actually the result of meticulous preparatory study, as attested in many marvellous drawings. Leonardo often asserted the need to explore a composition patiently rather than reproduce reality at a glance: 'The painter who draws through practice and judgement of the eye without reason is like a mirror that imitates the things placed in front of it without recognizing them.'

Virgin and Child with St Anne (cat. 19)

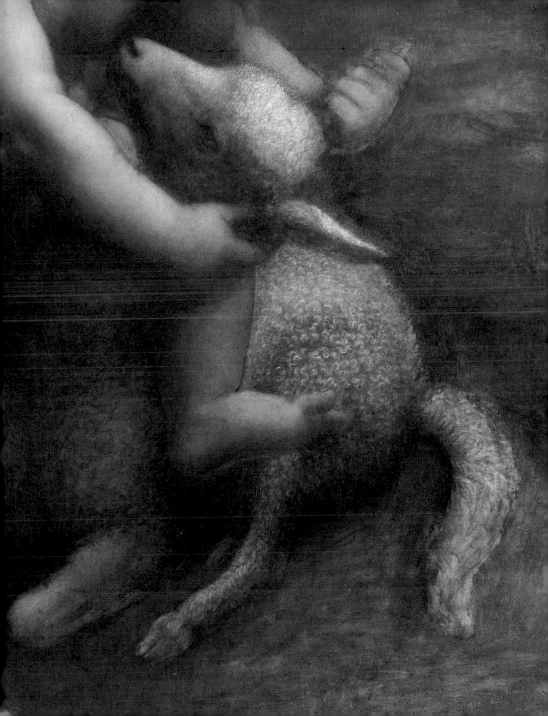

Children

WITHOUT MINCING WORDS, Leonardo labelled the act of procreation 'a disgusting thing'. One of his famous anatomical drawings illustrates the sexual act between a man and woman with the same cold indifference as if it were the workings of a piece of machinery. On the other hand, nothing fascinated him more than the mystery of the birth, formation, growth and renewal of life, and his drawings of the foetus in the mother's womb are among his most strongly felt and arresting. It is thus natural that Leonardo should have devoted more attention to children than almost any other painter of his time.

The Baby Jesus, depicted in the arms of the Madonna or in scenes revolving around the Nativity and the Flight into Egypt, is of course one of the most frequent subjects in European art. Nevertheless, for the entire Middle Ages and a good part of the fifteenth century, only rarely did artists really look at children – their poses, proportions, gestures and physical characteristics – instead relying most often on a traditional generic repertoire. Even though Leonardo was never a father, he was deeply interested in children. 'In men and children I find a great difference,' he asserted, underscoring above all the proportions of the head, much larger in babies 'because Nature gives the proper size first to the seat of the intellect'. He was a sympathetic observer of the awkward, timid movements of the smallest baby, sitting or standing, and noted the smoothness of their limbs, which were too often depicted as if they were 'wood' or 'a sack of walnuts'. Reflecting these observations, the master's paintings include a series of delightful and realistic children. In this area as well, Leonardo quickly progressed from conventional workshop practice – even if on the highest level – to a completely original way of working, free from constraints and models. Leonardo insisted that he always bore in mind the lessons of two masters: nature and experience. They, and not the imitation of other artists, led him to the 'judgement' that 'moves the painter's arms'.

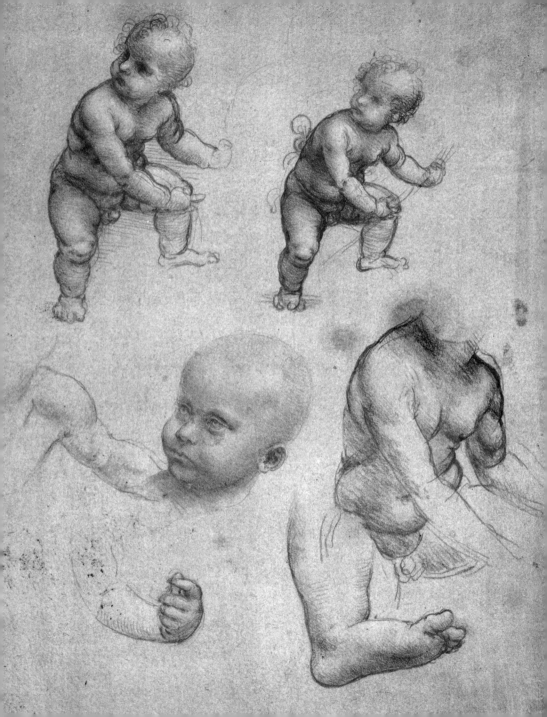

THE LONG AND COMPLEX EXECUTION of the *Virgin and Child with St Anne* occupied Leonardo for many years. This sheet of studies is evidence of his patient analysis of the poses and facial expressions as he sought a solution that always seemed to elude his hand. In it, Leonardo concentrates on the face of the Infant Jesus, which he changed radically in comparison with the cartoon today in the National Gallery in London, where the child is held in Mary's arm. Leonardo worked out a far more dynamic and natural gesture for the Child, who is trying to climb up on the back of a little lamb. No doubt based on observation of reality, this series of subtle variations on the face, arms, rotation of the upper body and even the toes never shows any loss of spontaneity or tenderness.

Study of a Child (cat. 44)

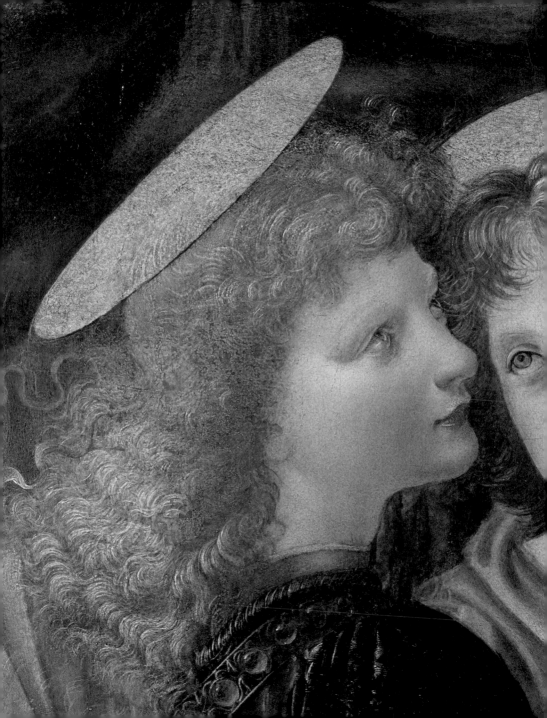

LEONARDO'S PAINTING CAREER BEGAN WITH AN ANGEL – an enchanting little boy in profile, with dreaming eyes and long, golden hair, who appears in the lower left of the *Baptism of Christ* altarpiece originally intended for the Vallombrosan convent of San Salvi in Florence. Designed and in part painted by Andrea del Verrocchio, the altarpiece was executed with the involvement of young pupils and co-workers from the workshop. The contribution of Leonardo, at the time just over twenty years old, stands out clearly in the soft use of shadow and the impassioned intensity of the expressions. According to Vasari, once Verrocchio had seen the beauty of the angel produced by his student's first efforts, he decided to abandon painting, symbolically breaking his brush, and to devote himself solely to sculpture and metalwork.

Baptism of Christ (cat. 2)

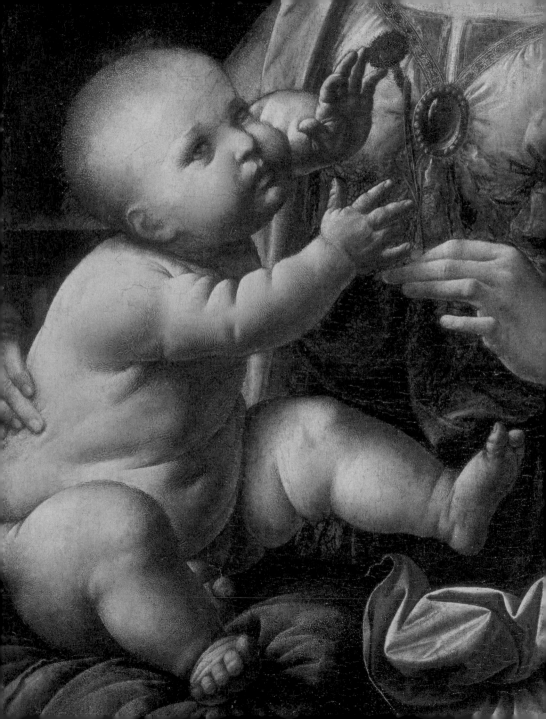

Among the works of Leonardo's first Florentine period, the *Madonna of the Carnation* met with particular favour from the Medici family. It is mentioned as being in the personal collection of the Medici pope Clement VII. The work falls within the period of greatest contact between the Tuscan and Flemish schools of painting. Leonardo does not suffer in comparison, as can be observed in the rich drapery of the Virgin's clothing, the vase of flowers at the right and the gleaming brooch mounted with a large topaz that stands out on the Virgin's breast. But the master's attention to reality in painting emerges above all in the way he painted the Child reaching for the carnation. This is indeed the gesture of a little baby who cannot yet focus his eyes or coordinate his movements. The fingers of the Madonna sink slightly into the Infant's fleshy side.

Madonna of the Carnation (cat. 6)

Not quite thirty years old, Leonardo composed a particularly complex and animated version of a frequent subject in fifteenth-century Florentine art: the Adoration of the Magi. Leonardo began an altar painting for the convent church of San Donato a Scopeto, near Florence, but left it incomplete when he went to live in Milan. The execution of the painting was subsequently entrusted to Filippino Lippi. Leonardo created a surprising scene: it is probable that he intended to arouse controversy by departing from the style of the era of Lorenzo the Magnificent, just as some of its most important exponents (Botticelli, Perugino, Ghirlandaio and others) were in Rome, decorating the walls of the Sistine Chapel. The Virgin and Child are not shown in the usual hut or cave but out in the open, under a tree, against an unsettling background of ruins. Amid all the figures crowded excitedly around, it is difficult to tell who the Wise Men are or how many there are – there are apparently more than the usual three. The detail of the Baby Jesus intrigued with a cup brought as a gift is of a pleasantly relaxed naturalness.

Adoration of the Magi (cat. 9)

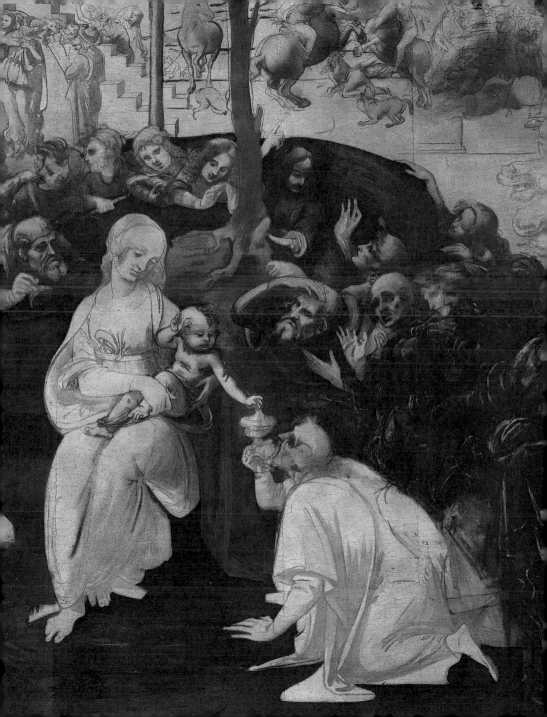

In Leonardo's life and stylistic development, the *Benois Madonna* belongs to a period of transition between his youth in Florence and his early maturity in Milan. A very young Mary plays and laughs with her Child, who is trying to focus his eyes on the little flowers as he grasps them in his tiny, plump hand. Leonardo – who must have observed the movements and characteristics of babies a few months old closely and at length – employed a wholly innovative realism to depict their appearance (including the fleshy folds of the wrists and the forearms), proportions and gradual acquisition of competence, control and hand-to-eye coordination.

Madonna of the Flower or the *Benois Madonna* (cat. 8)

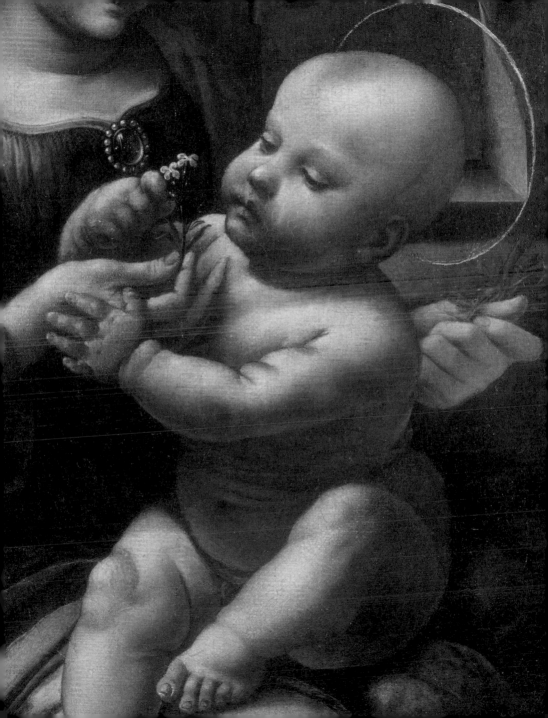

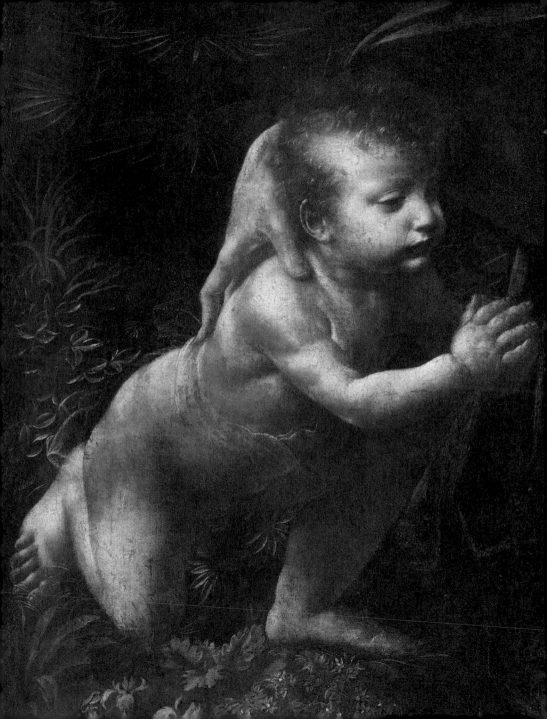

THE FIRST VERSION OF THE *VIRGIN OF THE ROCKS*, the sacred work with which Leonardo initiated his Milanese production, is a painting of explosive, even disconcerting, novelty. Beyond the unprecedented imaginary setting of a cave in the wilderness, one of the most innovative aspects is the vibrant and subtly ambiguous emotional atmosphere. In the first version of the work, today in the Louvre and entirely by Leonardo's hand, the artist did not indicate clearly which of the two children is Jesus and which is John the Baptist. The altar painting was meant for a chapel in the Milanese church of San Francesco Grande, no longer standing. After prolonged controversy, Leonardo kept the painting for himself. He had students paint a second version, today in the National Gallery, London, in which he added a slender reed cross beside the baby on the left with joined hands, thus identifying him as the Baptist.

Virgin of the Rocks (cat. 10)

THE GESTURES OF THE TWO INFANTS IN THE *VIRGIN OF THE ROCKS* are not entirely spontaneous. One kneels with his hands joined in prayer, the other raises his right hand in a sign of blessing. But these poses related to the composition's religious subject become human and realistic through the charming attention Leonardo devoted to the infantile faces, obviously observed from life. The child in profile (identifiable as Jesus thanks to an addition Leonardo made to the second version of the painting) shows the painter's capacity to reproduce typical features of little children, such as the chubby cheeks, serious expression and almost imperceptibly fine hair that captures the reflection of the sunlight.

Virgin of the Rocks (cat. 10)

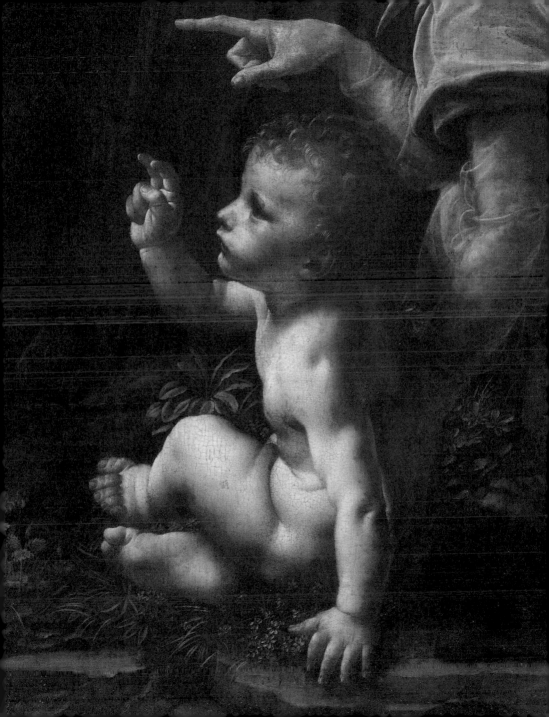

In the cartoon of the *Virgin and Child with St Anne and St John the Baptist*, Leonardo returns to the relationship between Jesus and John the Baptist as children, a theme he had already treated in the *Virgin of the Rocks*. There the two are on opposite sides of the painting, while here they are in direct contact. The painter stresses the age difference between the two, although, according to the Gospels, John is only a few months older than Jesus. As in the *Virgin of the Rocks*, the little Jesus is represented making a gesture of benediction, a frankly unnatural pose for an infant which Leonardo felt the need to 'counterbalance': with far greater spontaneity, Jesus extends his other, left arm to delicately caress the little St John's chin.

Virgin and Child with St Anne and St John the Baptist
('Burlington House Cartoon') (cat. 17)

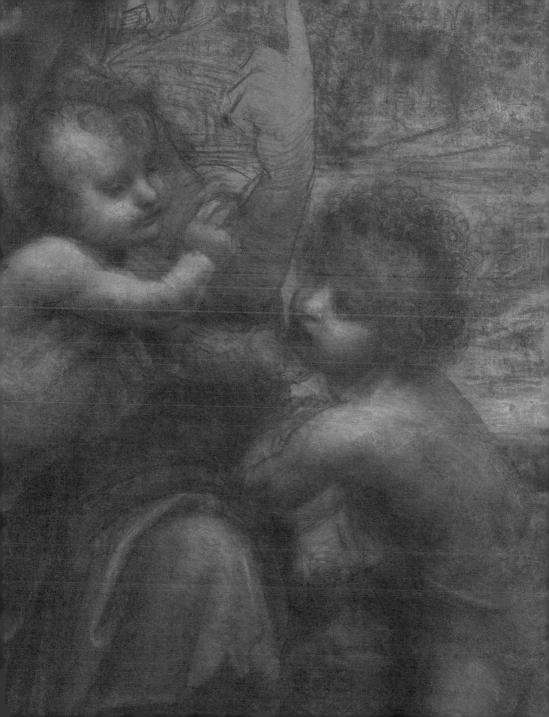

In the *Virgin and Child with St Anne*, the figure of the young John the Baptist found in the 'Burlington House Cartoon' is replaced by a lamb. It is a compositional choice that also clarifies the identity of the two women, because John is usually portrayed along with his mother, Elizabeth, rather than Anne. Leonardo radically changed the position and pose of the Baby Jesus, who turns to smile in the direction of the Madonna. The tilt of the head and eyes essentially repeats that of the St John in the London cartoon, and this overlap helps us grasp more clearly Leonardo's continual desire to change, correct, integrate and rework his compositions. Leonardo advised his fellow painters never to tire in the work of revision and to pay no attention to the cost or the income sacrificed in the long period of development: 'If you study and refine your work,' Leonardo stated, 'you will leave behind paintings that will bestow more honour upon you than money would.'

Virgin and Child with St Anne (cat. 19)

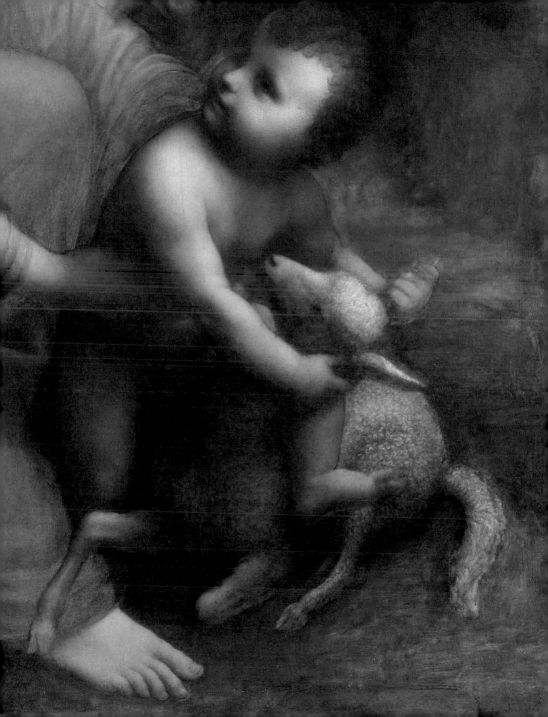

Gestures

With a mixture of embarrassment and coyness, Leonardo referred to himself as an 'unlettered man' – a person with little education and no literary culture. For a variety of personal, social and perhaps even functional medical reasons, as a boy Leonardo was unable to pursue a regular course of study. Since he progressed no further with Latin than the hard-won rudiments he learned on his own, it was impossible for him to read literary and scientific texts not translated into the vernacular. While on the one hand this lacuna limited his access to book knowledge, on the other it stimulated an exceptional capacity to acquire knowledge through the senses – the only way, he held, to acquire certainties. With proud confidence, he went so far as to assert that 'things are much more ancient than letters ... But sufficient for us is the testimony of things.' Arriving in Milan at the age of thirty, Leonardo faced a linguistic problem communicating at the Sforza court. Compared with the language of Florence, the Lombard language sounded truly foreign. This is reflected in the long word lists compiled by Leonardo in the Codex Trivulzianus, which some scholars interpret as an exercise in mastering the language. Images, however, need no translation. Convinced that painting is 'mute poetry', the artist sought to make his compositions more eloquent and lifelike, filling them with facial expressions and hand gestures of a new, more direct expressiveness.

To achieve this goal, Leonardo made use of some unusual devices. He carefully observed deaf-mutes' ways of communicating through gesture, and he analysed how successful public speakers reinforced their words with a deliberate expressive use of their hands, facial mimicry and movements of the body. The most obvious result is no doubt *The Last Supper* at the refectory of Santa Maria delle Grazie in Milan. For centuries considered an unsurpassable example of non-verbal communication, *The Last Supper* is a full demonstration of one of Leonardo's most famous statements: 'That science is most useful whose fruits are most communicable, and thus conversely that which is less communicable is less useful. The end results of painting are communicable to all the generations of the universe ... [The eye] has no need for translators from various languages.'

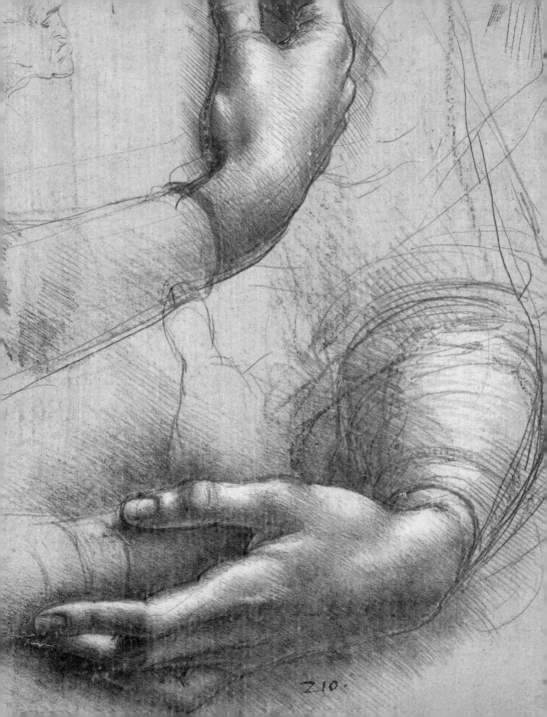

AT ONE TIME THOUGHT TO BE RELATED TO THE LOWER PART of the portrait of Ginevra de' Benci and subsequently lost, today this famous and marvellous drawing is generally considered to be a preliminary study for the hands and lower arms of *Lady with an Ermine*. That requires a change of dating, from the early Florentine period to the early maturity in Milan. It is an example of the attention Leonardo paid to the non-verbal language of gestures, an indispensable key to communication through painting. Leonardo was left-handed, which explains his habit of writing 'backwards' and some of his characteristic use of the pencil and brush. Aware of possessing the gift of an exceptional hand, Leonardo praised painting as a 'science' reserved to a privileged few: 'It cannot be taught to someone not endowed with it by nature, as can be done with mathematics, in which the pupil takes in as much as the master gives out ... It cannot produce infinite offspring like printed books. Painting alone retains its nobility, bringing honours singularly to its author and remaining precious and unique.'

Study of a Woman's Hands (cat. 33)

Even in this small panel measuring just a few centimetres from the beginning of his career, Leonardo was able to bring the emotional relationship of the figures into sharp relief through the expression of not only their faces but also their gestures. In the *Dreyfus Madonna*, the narrative core is concentrated on the juxtaposition of the two figures' faces and their hands. Mary gently raises a little flower in her tapering fingers, and the Child extends his still-awkward hand to almost crush the petals and leaves. The same theme would be explored again in the *Madonna of the Carnation* and the *Benois Madonna*, evidence of Leonardo's attention to the developing coordination and refinement of the senses during the first months of an infant's life.

pp. 86-87

Reflecting the unfolding of the Gospel story and the dialogue between the Archangel Gabriel and the Virgin Mary, Florentine painters represented Mary's mood at the moment of the Annunciation in different ways: humility, surprise, prayer, interchange, anxiety and so forth. In this early work, Leonardo's first important independent painting, he explicitly breaks with his Florentine colleagues by choosing calm gestures and tranquil expressions. In the future, the 'movements of the soul' would become more accentuated in his paintings. Mary's long, supple hands recall the precious, idealized style of Botticelli. Mary rests her right hand on a book lying on an elegant lectern, similar to sculptures executed in the workshop of Verrocchio. Her raised left hand expresses a slight, controlled surprise.

Madonna and Child with a Pomegranate, or the *Dreyfus Madonna* (cat. 1)
pp. 86-87 *Annunciation* (cat. 3)

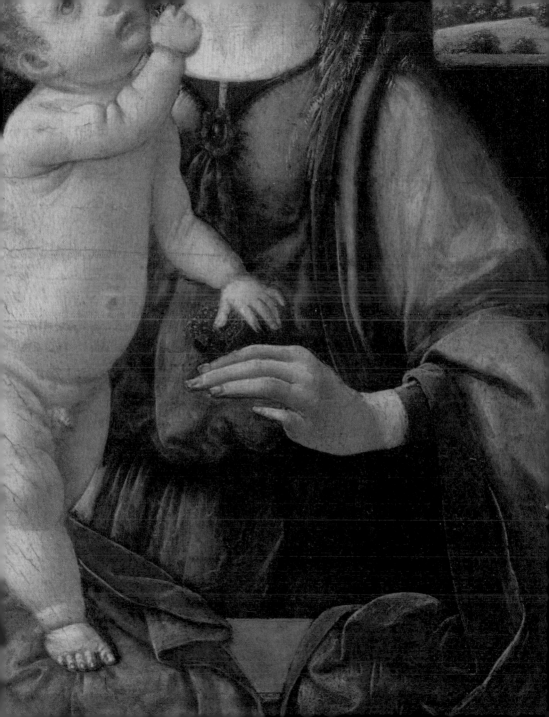

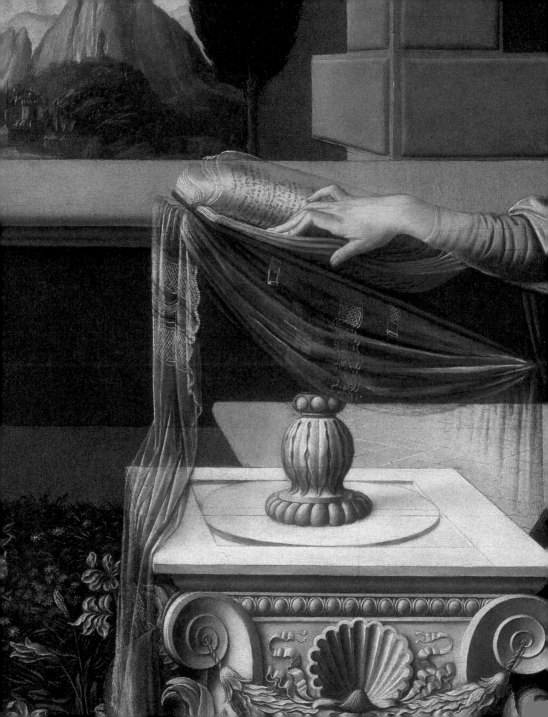

MARY'S PROTECTIVE HAND EXTENDS FORWARD; that of the angel points decisively; the Christ Child raises a hand in blessing. The three gestures, emerging from the shadows, are arranged close together, one above the other to form the expressive nucleus of the *Virgin of the Rocks*. Here we have another of Leonardo's surprising innovations: filling the figures with movement, conveying the restlessness of the action taking place, superimposing the various actors' gestural messages. Leonardo thus sets himself in distinct opposition to the quiet, calm scenes painted by masters like Perugino with their reassuringly ordinary landscapes and mild, sweet figures in languid, repetitive poses. Instead, the *Virgin of the Rocks* offers an extraordinary variety of gestures, some of which, like the foreshortened hand and the forward-pointed index finger, would be especially influential in art history.

Virgin of the Rocks (cat. 10)

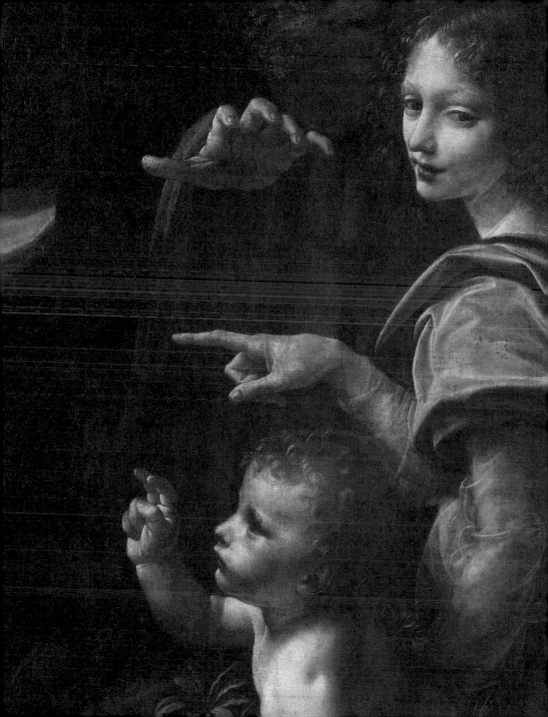

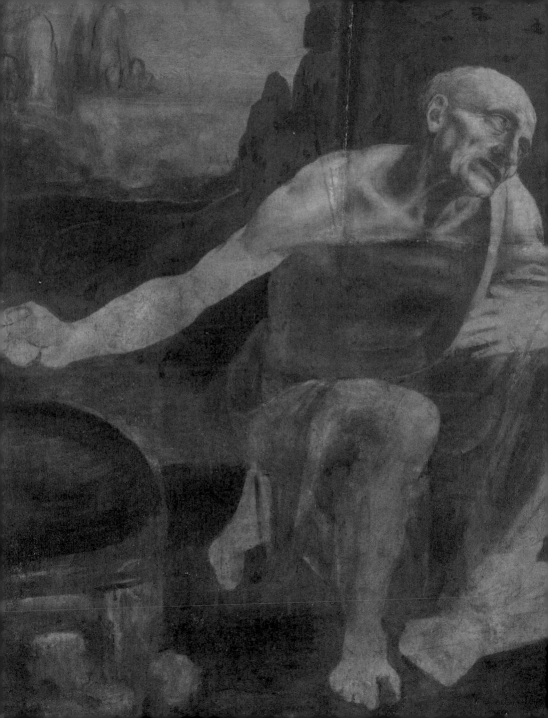

REMAINING IN AN INTERMEDIATE STATE BETWEEN PAINTING AND DRAWING, this work shows Leonardo's exceptional graphic ability. The figure of the saint, who is flagellating himself as a sign of penitence, is defined with a precision that brings out the physical and spiritual tension. Leonardo engaged in a kind of long-distance dialogue with the sculpture of Verrocchio to give the saint's face and body a three-dimensional strength and characterization, as if it were a clay statue. The deeply furrowed face and neck, toothless mouth and hollow eyes emphasize the scene's intense pathos. According to the most recent studies, this painting does not belong to Leonardo's youthful Florentine period, despite its reference to Leonardo's training under Verrocchio, but must have been executed in Milan shortly after the *Virgin of the Rocks*, of which the fascinating natural 'architecture' of rocks and caves is reminiscent.

St Jerome (cat. 11)

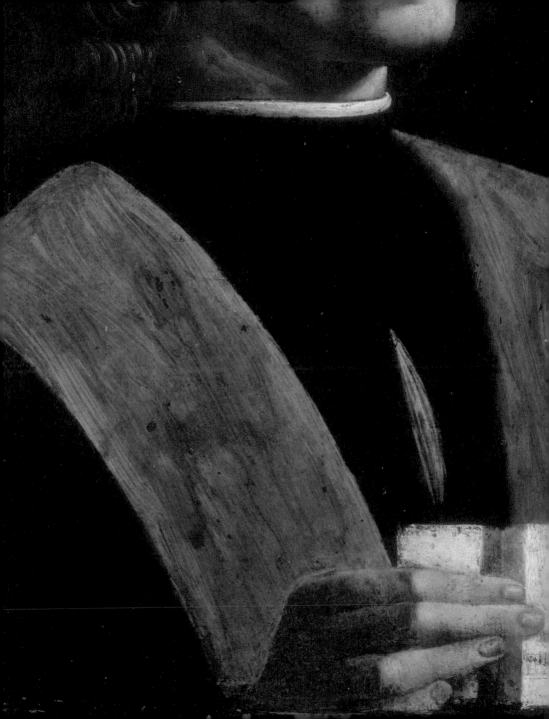

That the sitter is a musician is revealed by an unmistakable detail: the score he holds up in his right hand. Various hypotheses on the man's identity have been formulated. The most probable suggests that he is Franchino Gaffurio, the *maestro di cappella* at Milan's cathedral and an eminent author of treatises. He might also be the virtuoso lutenist Atalante Migliorotti, who went from Florence to Milan with Leonardo, or else Josquin des Prez, who directed the choir of Flemish choristers at the chapel of the Castello Sforzesco in Milan. In any case, it is a tribute to the brilliant musical life of Milan at the time of Ludovico il Moro. Leonardo knew music well: he built brilliant-sounding instruments, he enjoyed listening to musicians perform while he painted, and some of the passages in the codices have been interpreted as drafts for potential love songs – for example 'The lover moves towards the thing loved: / ... if the thing loved is vile, the lover is made vile; / When the lover is joined to the beloved, there it rests.'

Portrait of a Musician (cat. 12)

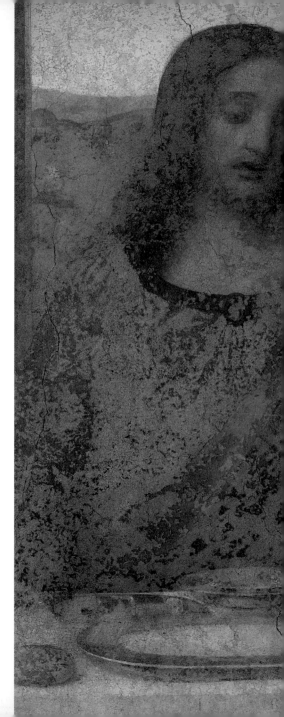

Leonardo had to contend with problems of communication, comprehension, translation and writing his whole life. He was obsessed by the desire to be truly understood as a man, a scientist and an artist. Unfortunately, he was very often misinterpreted. *The Last Supper* is one of the world's most famous paintings, imitated and copied by generations of painters. But very few overcame the ordinariness of the replica, the monotony of the copy. The painting has been overused in myriad reproductions, while the ravages of time and taste have covered its surface with dirt, soot and repainting. During World War II, the refectory of Santa Maria delle Grazie was gutted by bombardments, but the wall with *The Last Supper*, protected only by sandbags, remained standing in the middle of the ruins. An extremely lengthy restoration has given us back the flakes and chips that survive from the original painting. Looking at *The Last Supper* today means understanding the profound meaning of a deeply felt masterpiece of robust intensity.

The hands in this detail, taken from the very centre of the scene, play a revealing narrative and psychological role. Resting inert on the table, Christ's left hand expresses a sense of resignation. James's outspread arms and parted lips communicate a pained amazement. Thomas raises his right index finger in a gesture of questioning and doubt, foreshadowing his incredulity when, upon encountering the risen Christ, he says that in order to believe, he must 'put his finger' in the Lord's wounds.

The Last Supper (cat. 14)

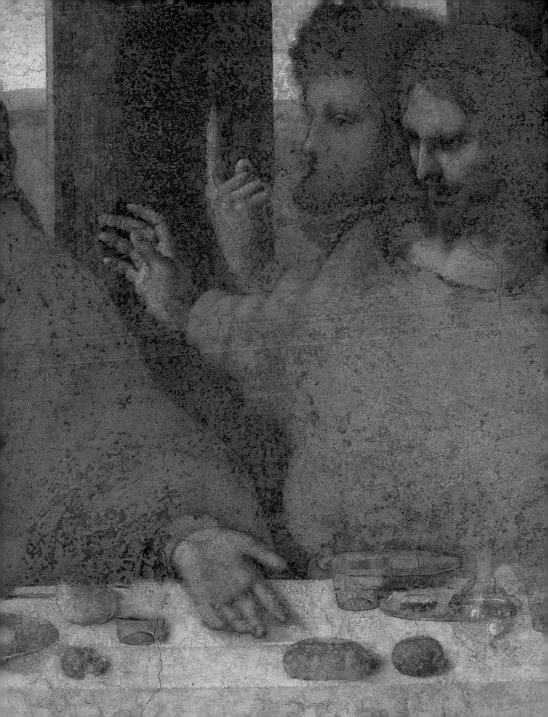

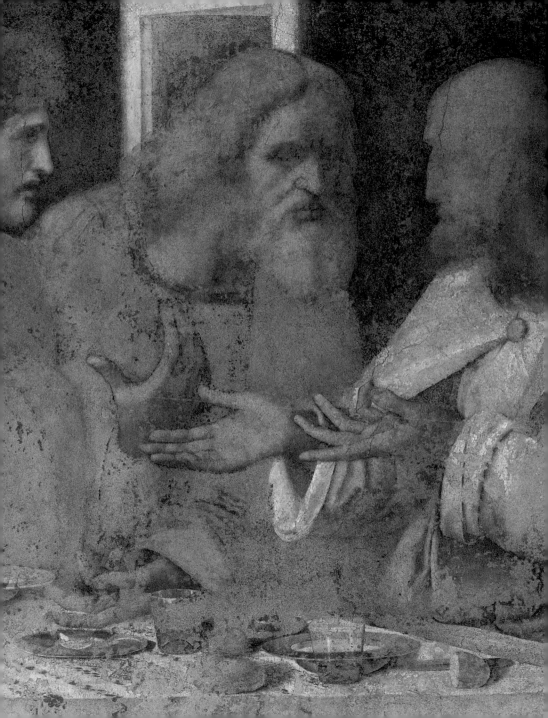

The Last Supper is the most impressive demonstration of Leonardo's exceptional ability to capture and reproduce emotions through the face, hands and bodily movement. In 1497, responding to the more emotional aspect of *The Last Supper*, the famous mathematician Luca Pacioli, its earliest commentator, wrote, 'It is difficult to imagine a greater form of attention given to the Apostles' animation.' Each of the Apostles reacts to Christ's words in a different way, expressing – as Leonardo himself said – 'his actual mental state'. This theme became almost an obsession for Leonardo, who thought of painting as poetry without words. To make the Apostles' emotions more obvious, while working on *The Last Supper* he carefully observed the sign language of deaf-mutes, in addition to seeking inspiration in the facial expressions and hand gestures with which orators reinforce their spoken message.

The Last Supper (cat. 14)

Among Leonardo's opinions on painting that Francesco Melzi collected into a treatise after his death, there is much advice concerning the expression of feelings - for example, 'Capture figures in the act that suffices to show what the figure has in its soul. Otherwise your art will not be worthy of praise,' and do this, he adds, 'as much as possible'. The Apostles' gestures in *The Last Supper* are like concentric waves of emotion within a regular structure. Leonardo divided the figures symmetrically into four groups of three around the central figure of Christ. The actions of the Apostles nearest the centre, like Philip, reproduced here, obviously express strong feelings and intense physical and emotional involvement. Moving towards the outside of the composition, the gestures gradually become calmer, more reflective and inward.

The Last Supper (cat. 14)

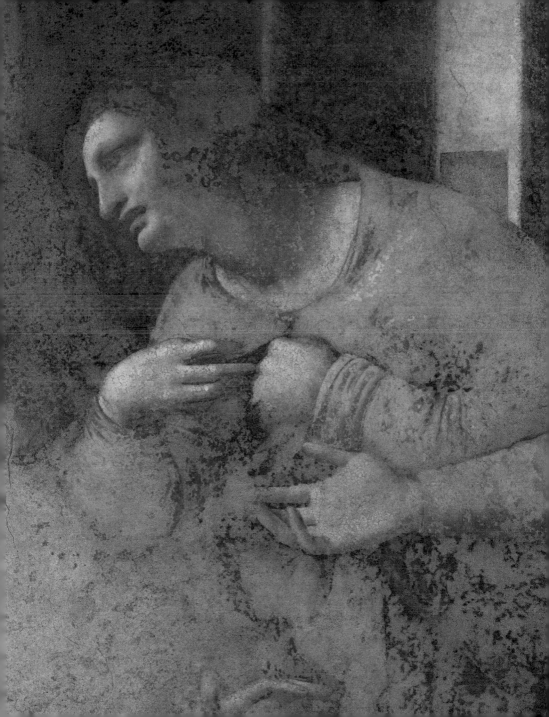

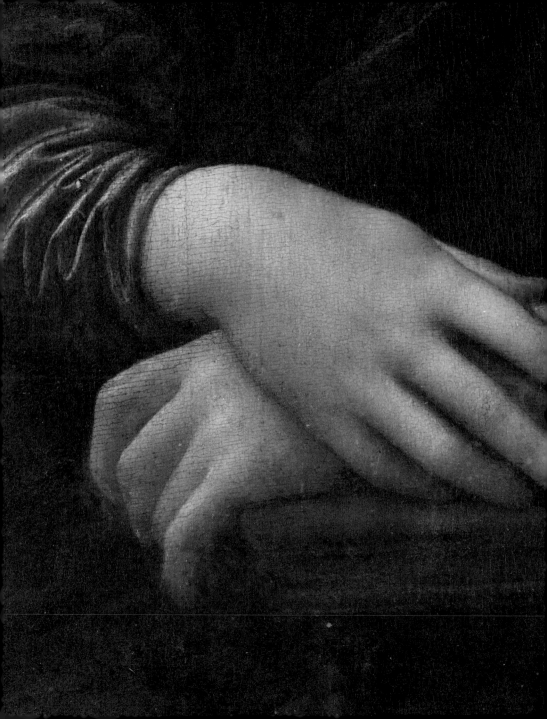

Thirty years after Leonardo's *Portrait of Ginevra de' Benci*, the *Mona Lisa* again presents a figure immersed in a natural setting. However, the earlier painting's symbolic references have been replaced with innovative tonal and psychological values. There is perfect harmony between the background and the emergence of a feeling and personality that seem to be reflected in the changing hazy atmosphere and jagged topography of the landscape of water and mountains. The relaxed bearing, with the hands resting one upon the other and the slight twist of the upper body, was immediately and accurately taken up by Raphael for the female portraits he painted during his stay in Florence.

Portrait of Lisa Gherardini, called the *Mona Lisa* or *La Gioconda* (cat. 18)

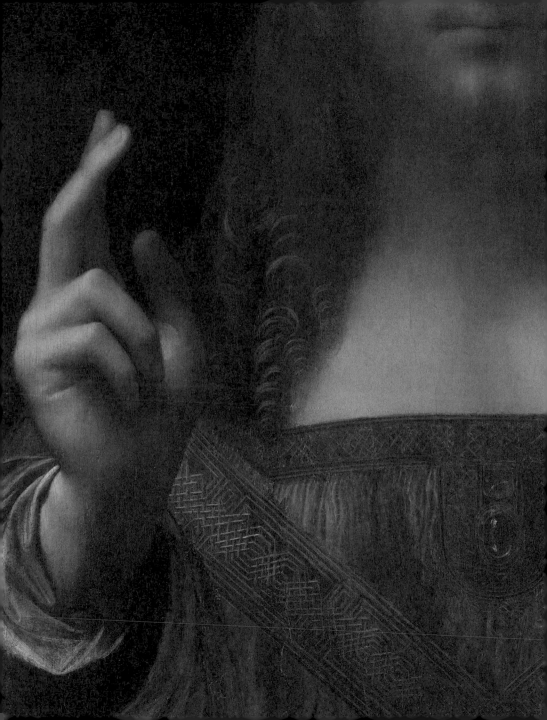

THE HAND RAISED IN BENEDICTION, with index and middle fingers pointing upwards and ring finger and little finger curled down, conforms to the iconographic repertoire of Christ as Saviour of the World. Around this painting, which was recently the object of a sensational sale, revolve a dozen similar images, all dominated by the frontal figure of Christ blessing and all relatable to Leonardo's time, place and style. Critical opinion is increasingly divided as to whether the painting today in the Arab Emirates is by the hand of Leonardo (bearing in mind the imperfect state of conservation). Its date is also a matter of debate, though it most probably belongs to the period of the painter's second stay in Milan.

Salvator Mundi (cat. 21)

THE HAND HOLDING A CRYSTAL SPHERE is the most significant and best-preserved detail of this controversial but fascinating painting. Leonardo keeps to the traditional iconography of Christ, Saviour of the World, holding a globe that symbolizes the cosmos in his left hand. It is not unlike the orb represented in the hand of emperors as a sign of their power. Upon examining the object, we notice that Leonardo has depicted not a hollow blown-glass ball but a full, solid sphere carved from a block of rock crystal. Within the crystal are embedded fossils, which Leonardo has observed with meticulous attention. Rock crystal was extracted from natural Alpine caves in the Valtelline, in southern Lombardy. The presence of this refined material led to the founding of workshops in Milan during the sixteenth century that specialized in sophisticated rock-crystal luxury objects turned on a lathe.

Salvator Mundi (cat. 21)

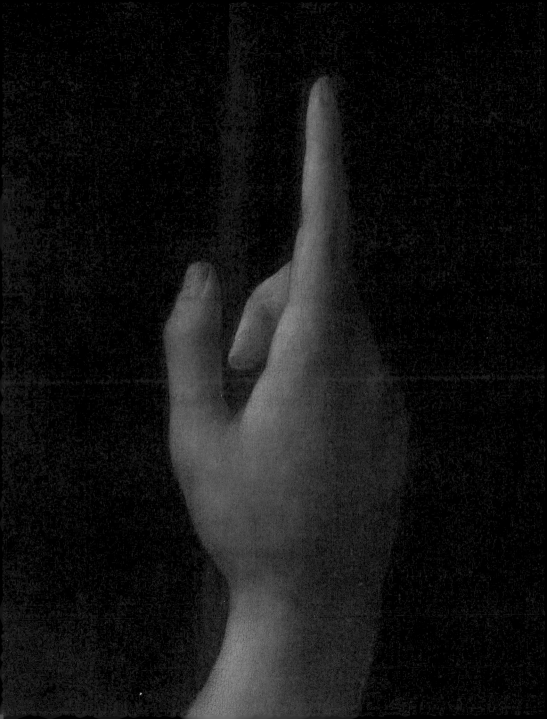

PERHAPS THE LAST GESTURE THAT LEONARDO'S BRUSH LEFT US is this finger pointing to the sky, as if visually embodying the famous motto Leonardo derived from Dante: 'He who is fixed to a star does not change his mind.' Close scrutiny reveals that the hand does not firmly grasp the small reed cross (a typical attribute of St John the Baptist), which almost seems to have been added to identify the curly-headed young man with an insinuating smile as the Precursor who announces the coming of Christ. The index finger upraised interrogatively, or – as here – to suggest that we look to the world above, is a characteristic gesture found in various of Leonardo's figures, such as St Thomas in *The Last Supper* and St Anne in the 'Burlington House Cartoon'. In the Vatican Palace's Stanza della Segnatura, Raphael depicted an idealized gathering of great philosophers in the so-called *School of Athens*: Plato and Aristotle occupy the centre of the scene; Plato, who points to the sky with a gesture that has obviously become unmistakable, has Leonardo's features.

St John the Baptist (cat. 22)

THE POINT OF DEPARTURE FOR THE WHOLE OF LEONARDO'S ACTIVITY as a painter and researcher was a passionate love of nature. From his early childhood until the last days of his life, Leonardo never ceased being moved by not only solemn sights (majestic mountains, thundering cataracts, swirling clouds, snowy peaks) but also little everyday miracles: a blossoming flower, a dewdrop, the wind caressing the fields. It is not by chance that his first dated work (5 August 1473) is a drawing of a Tuscan landscape and the last images are vortices and overwhelming cataclysms.

Leonardo, who never went out of doors without a notebook within hand's reach, teaches us to look at the world with new eyes, to become part of the pulse, the 'respiration of this our terrestrial machine' as an enormous living organism.

Leonardo's main point of reference in establishing a harmony of art, technology and science was the mystery of life, a solemn synchronous breathing in all the kingdoms of nature and various human activities. His pantheism was the outgrowth of deep reflection on existence, free of any traditional religious creed. He felt he was part of a universal mechanism supported by a supreme intelligence that created and regulated the world and the cosmos on the basis of a few simple laws – a perfect rhythm of continual regeneration that does not decline, age or tire. A true religion of nature.

Lacking investigatory tools, Leonardo placed his senses in the service of his intelligence, making his physical and intellectual faculties function as a means of understanding the laws that regulate the universe. Nonetheless, he was not a scientist, philosopher or technician. He was aware – and proud – of being foremost a painter. According to Leonardo, painting is 'the grandchild of nature and related to God' and 'considers all qualities of forms philosophically and with subtle deliberation: air and landscapes, plants, animals, herbs and flowers'. In drawings and paintings, his analysis is suddenly clothed in the colours of feeling, involvement, a joyous love of nature and, at the same time, an unusual capacity to grasp the nuances of the human animal, to intuit the psychology of people.

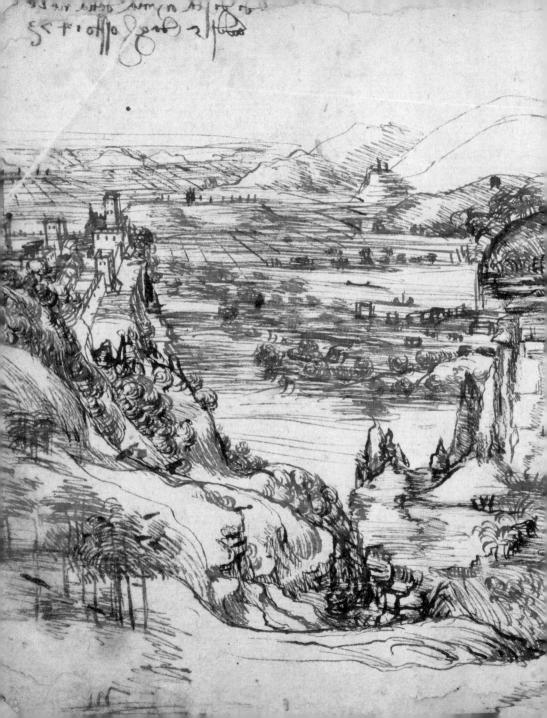

THE INVALUABLE HANDWRITTEN ANNOTATION in the upper left corner of this drawing dates it to 5 August 1473. It is significant that this first dated drawing by the 21-year-old Leonardo depicts a landscape. The specific site has not been identified, nor is it even certain that the drawing represents an actual view. Nevertheless, the haunting uninhabited scene is certainly in Leonardo's native Tuscany. With its rivers meandering along valley floors, cliffs, wooded plains, rocky outcroppings and castles keeping watch over the valleys below, it is a landscape of the soul of the kind Leonardo would continue to explore on long walks throughout his life, observing it with his eyes, mind and heart.

Tuscan Landscape (cat. 24)

THE BACKGROUND OF THE *BAPTISM OF CHRIST* is in all probability the work of the young Leonardo. The contrast between the firm, flat drawing of the palm tree and the quivering sfumato of the river landscape clearly shows the presence of two different hands. The young artist's talent began to assert itself in the workshop of Andrea del Verrocchio, especially in the representation of nature.

Leonardo made a famous statement about the power of painting, and this proud affirmation of the creative force of the artist, considered almost as a divine demiurge, focuses on landscape: 'The painter is lord of all things that may come to a man's mind, and so if the painter wishes to see beauties that would enrapture him, he is master of their production. And if the painter wants to see monstrous things that frighten, or that are grotesque and laughable, or those that arouse real compassion, he is of them the lord and creator ... If he wishes to produce places or deserts, or shady and cool spots in hot weather, he can depict them. If he seeks valleys, the same is true. If he wants to disclose great expanses of countryside from the summits of high mountains, and if he subsequently wishes to see the horizon of the sea, he is the lord of them, or if from low valleys he wishes to see high mountains, or from high mountains low valleys and beaches.'

Baptism of Christ (cat. 2)

ANOTHER DETAIL FROM THE *BAPTISM OF CHRIST* very likely attributable to the novice Leonardo da Vinci is the fresh and transparent Apennine stream that represents the River Jordan. Christ's feet are submerged in the water, in a riverbed of sand and pebbles. With passionate accuracy, the painter observed and reproduced the tiny eddies and waves that form around the ankles. For his whole life, Leonardo would always be struck by the 'flow and reflux' of moving water, from ocean waves to smaller bodies of water dotting the countryside.

Baptism of Christ (cat. 2)

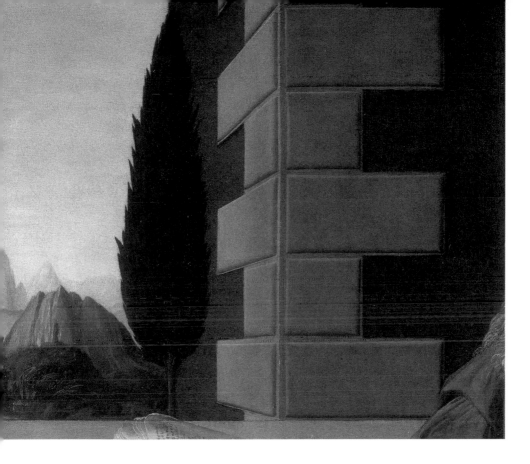

FORMERLY IN THE OLIVETAN MONASTERY OF SAN BARTOLOMEO near
Florence, this painting was one of Leonardo's first independent
works. The Annunciation was a frequent religious subject in fifteenth-
century Florentine art. Aware of measuring himself against the great
artists of his city, the young Leonardo chose an innovative open-air
setting, whereas the scene is usually set in Mary's bedroom or under a
portico. Leonardo moves it to the entrance parterre of an elegant villa,
closed off by a low wall. The background includes the crowns of trees
depicted with botanical precision.

Annunciation (cat. 3)

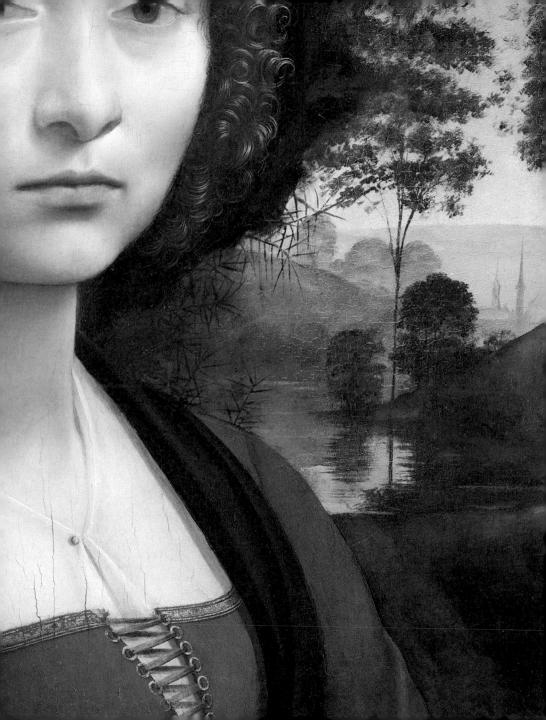

IN THE YOUTHFUL PORTRAIT of the Florentine lady Ginevra de' Benci, Leonardo gives early evidence of his keen observation of nature and his taste for wordplay. A thorny bush rises behind the woman, creating an effective contrast with the light sky and alluding to the woman's name (*ginepro* is Italian for 'juniper'). The landscape is also haunting for the contrast between the light background and the dark juniper bush that serves as a screen behind Ginevra's shoulders. In subsequent portraits painted for the Sforza court in Milan, Leonardo adopted a neutral background. He was not to set another female portrait in a landscape for more than thirty years, again in Florence, with the *Mona Lisa*.

Portrait of Ginevra de' Benci (cat. 4)

The back of the *Portrait of Ginevra de' Benci* bears the motto
Virtutem forma decorat ('Beauty adorns virtue'), probably a saying of the
Venetian humanist Bernardo Bembo, with whom the young woman
maintained an exchange of letters. The inscribed scroll is intertwined
with three symbolic fronds depicted with botanical accuracy: laurel,
myrtle and palm, alluding to the young woman's intellectual gifts,
matrimonial virtue and purity, respectively. Myrtle, connected with the
theme of marriage, may be understood in the context of the wedding
of Ginevra de' Benci and Bernardo Niccolini, which took place in 1474.
The heraldic composition is abruptly cut off at the bottom, lending
credence to the theory that the portrait's dimensions were greatly
reduced by eliminating the coat of arms.

Reverse of the Portrait of Ginevra de' Benci (cat. 5)

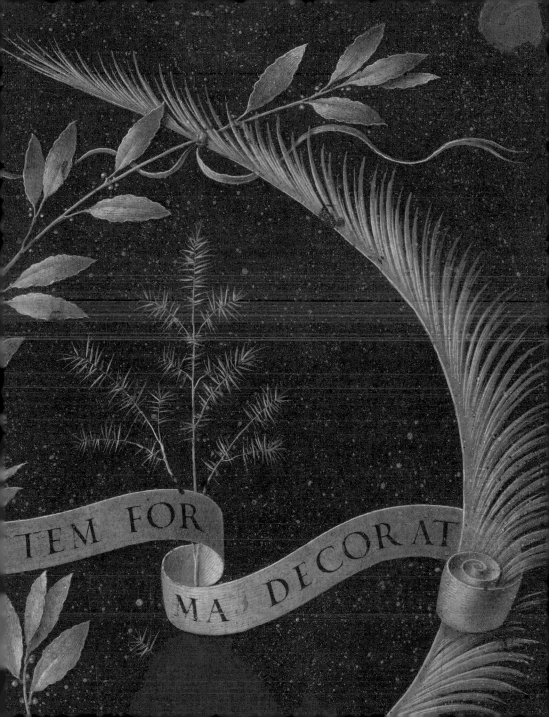

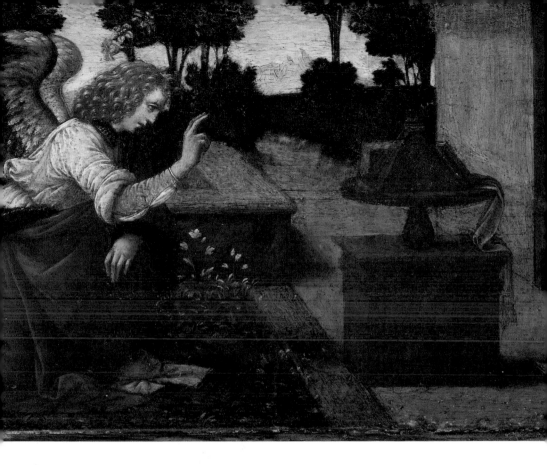

THE SMALL ELONGATED POPLAR PANEL OF THE *ANNUNCIATION* was
originally part of the predella of an altarpiece commissioned from
Verrocchio for the cathedral of Pistoia, where it is still to be found.
Verrocchio entrusted the execution of the work to his collaborators.
The main painting is one of Lorenzo di Credi's best works; many
scholars consider the Louvre's *Annunciation* to be the contribution of
Leonardo, because of its obvious affinity with the larger painting of
the same subject now at the Uffizi. The natural setting imparts an
extraordinary delicacy to the scene. The garden seems to blossom
luxuriantly around the figure of the Archangel Gabriel. The Feast of
the Annunciation is 25 March and thus coincides with the beginning of
spring.

Annunciation (cat. 7)

THE ONLY ALTAR PAINTING executed by
Leonardo during his first long stay in
Milan was originally at the church of
San Francesco Grande, in a chapel that
was subsequently demolished. However,
Leonardo did not hand this version
over to the commissioning patrons but
replaced it with the replica today at the
National Gallery, London, painted under
the supervision of Giovanni Ambrogio
de Predis. The meeting between John
the Baptist and the Child Jesus, in the
presence of the Madonna and an angel,
takes place in an impressive natural
setting: a damp grotto among the rocks,
as if in the womb of Mother Earth.
Light filters from the cave's openings,
brightening the shadows. The innovative
representation of a rocky cave coincides
with Leonardo's poetic memory of a forest
excursion: 'I came to the entrance of a
great cavern, in front of which I stood
some time, astonished and unaware of
such a thing. Bending my back into an
arch I rested my left hand on my knee and
held my right hand over my downcast and
contracted eyebrows, often bending first
one way and then the other to see whether
I could discover anything inside, and this
being forbidden by the deep darkness
within, and after having remained
there some time, two contrary emotions
arose in me, fear and desire – fear of the
threatening dark cavern, desire to see
whether there were any marvellous things
within it.'

Virgin of the Rocks (cat. 10)

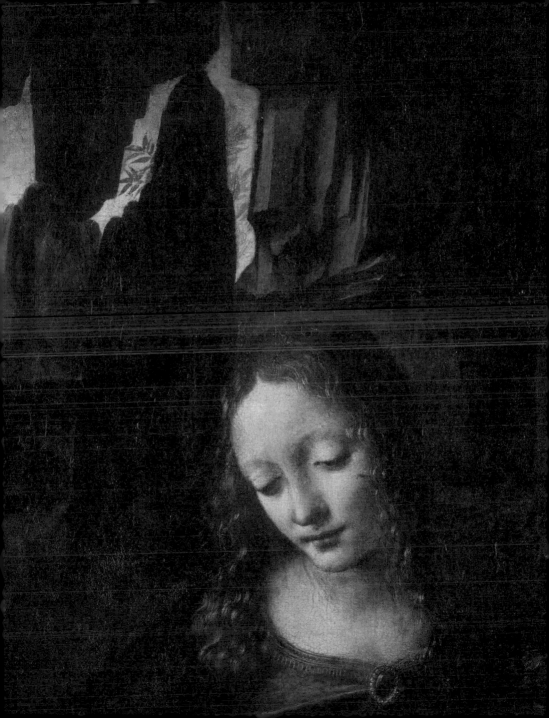

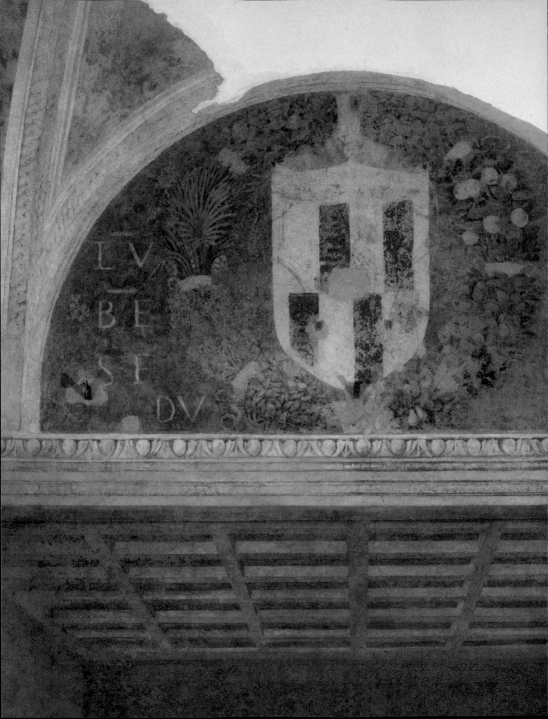

In *The Last Supper* there are not only figures and objects on the table, but also arresting natural sections in the luminous landscape behind Christ and, above all, in the luxuriant vegetation of the lunettes. Leonardo painted four of these: three that overlook the scene and one nearby on the left wall. They are better conserved and more legible than the main scene. Nonetheless, they are sometimes overlooked by visitors because of their height. The clearly distinguishable leaves and fruit of the various trees are partly connected to the rich heraldic vegetation of the dukes of Milan.

The Last Supper (cat. 14)

THE SALA DELLE ASSE IS A ROOM in one of the perimeter towers of the Castello Sforzesco. The ceiling decoration consisted of intertwined branches and leaves, and long knotted cords supporting coats of arms and inscriptions relating to Ludovico il Moro. Leonardo was probably inspired by the architectural illusions and set decorations that Mantegna produced in the Camera degli Sposi in Mantua, a courtly atmosphere identical to that of Milan. Owing to the historical vicissitudes of the Castello Sforzesco, Leonardo's decorations almost completely disappeared. On the basis of faint traces, they were repainted during major restoration and reconstruction of the entire building in the early twentieth century. Further delicate conservation treatments are in progress with the aim of discovering how much of the original remains.

Sala delle Asse (cat. 16)

· LVDOVICVS · MEDIOL · DVX ·
MEDIOL · DVCATVS · TITVLVM · IVSQVE ·
· QVOD · MORTVO · DVCE · PHILIPPO · AVO ·
IN · GENTE · SFORTIANA · OBITENERE ·
· NON · POTVERAT · AB · DIVO · MAX · RŌ ·
REGE · IMPERATOREQVE ·
MAGNIS · CVMVLATVS ·
HONORIBVS · ACCEPIT ·

AN · SAL · LXXXXV ·
SVPRA · MCCCC

THE CEILING of the Sala delle Asse is difficult to assess in its completely repainted state, though the careful conservation treatment in progress will hopefully restore the traces of the original painting. In the meantime, the monochrome fragments in the lower part of the walls are of considerable interest. They are visible evidence of the extraordinary dialogue between painting and nature conceived by Leonardo. Sixteen mulberry trees were painted along the walls of the heavy square tower that houses the hall – an allusion to the development of the silk industry in Lombardy under Ludovico il Moro (the leaves of the mulberry tree provide silkworms' food). The trees' roots struggle against blocks of stone, at times splitting the rock in a dramatic contrast that expresses the force of nature.

Sala delle Asse (cat. 16)

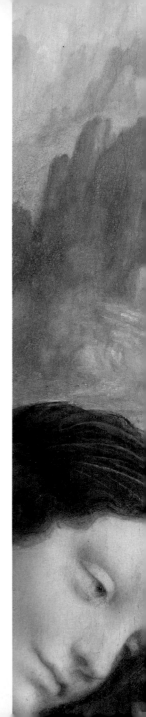

The long walks in Tuscany and Lombardy described in the codices and referred to in Leonardo's drawings and paintings are memorable. The artist communicates his passion for inaccessible mountainous places like Monte Rosa, climbing which gave him the opportunity to observe the formation of clouds and of fog on the lakes below, walls of rock and foreshortened panoramas viewed 'as the bird flies'. In the long working-out of the *Virgin and Child with St Anne*, a marvellous background landscape at the foot of the Alps eventually took shape, with imposing summits that rise above the mist. We feel Leonardo's free and passionate spirit resonate as he exclaims, 'What moves you, O man, to abandon your houses in the cities and leave your family and friends and go into the countryside through mountains and valleys, if not the natural beauty of the world?'

Virgin and Child with St Anne (cat. 19)

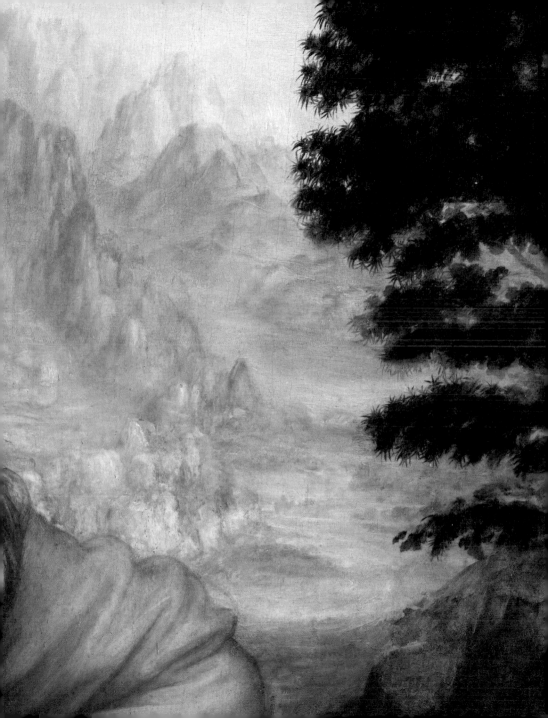

Gazes

THE PAINTINGS OF LEONARDO ARE UNFORTUNATELY FEW, but their rarity increases their fascination and perhaps heightens their mystery. They all possess a characteristic – a magnetism, an empathy, a direct relationship with the viewer – that makes them unique. Leonardo pierced through the wall that separates the space-time of the observer from the space-time of the painting. As he wrote, 'That figure is most praiseworthy which by its action expresses the passions of its soul.' This creates a new and intense relationship, a true exchange of feeling.

Vasari provides explicit testimony of Leonardo's jovial character: he could 'calm the saddest soul' and 'drew people's spirits to himself'. But the codices reveal a darker aspect. One famous passage asserts Leonardo's desire for total creative independence: 'If you are alone, you belong entirely to yourself. If you are accompanied by even one companion, you belong only half to yourself or even less in proportion to the thoughtlessness of his conduct, and if you have more than one companion, you will fall more deeply into the same plight.' Leonardo could appear to be refined and distinguished, sociable and brilliant, quick to astonish with his cheerful-coloured clothing of unusual cut. But in his private life and especially his artistic work, he preferred to hold dialogue with himself, his works and his own research. As a rule, communication took place mainly through sight, through the eyes. As a philosopher, artist and scholar, Leonardo devoted continuous attention to the eye, even devising a method of making an eyeball more solid in order to dissect it and study its anatomy. 'The eye, which is called the window of the soul, is the principal means by which the central sense can most completely and abundantly appreciate the infinite works of nature,' he wrote, and in various notes we sense his anxiety at the thought of losing his eyesight, the most precious of the senses. The silent yet profound exchange that takes place between the viewer and Leonardo's figures passes above all by way of the intensity of the gaze, which allows us to go beyond the appearance of things and persons to reach the depths of thought and emotion. This is encapsulated in one of the master's most potent statements: 'A good painter has two main objects to paint: man and the intention of his soul.'

Called by Kenneth Clark 'the most beautiful drawing in the world', this image is generally thought to be a preparatory study for the angel in the *Virgin of the Rocks*. However, there are those who believe it is actually a portrait of a young girl drawn from life, and others even claim that the model is Cecilia Gallerani, the 'Lady with an Ermine'. The charm of this wonderful drawing, which is considered one of the first masterpieces Leonardo executed in Milan, lies above all in the intense, profound, delicate expression, with the sitter's eyes, turned towards her shoulder, gently brushing the viewer's gaze.

Head of a Young Woman (cat. 30)

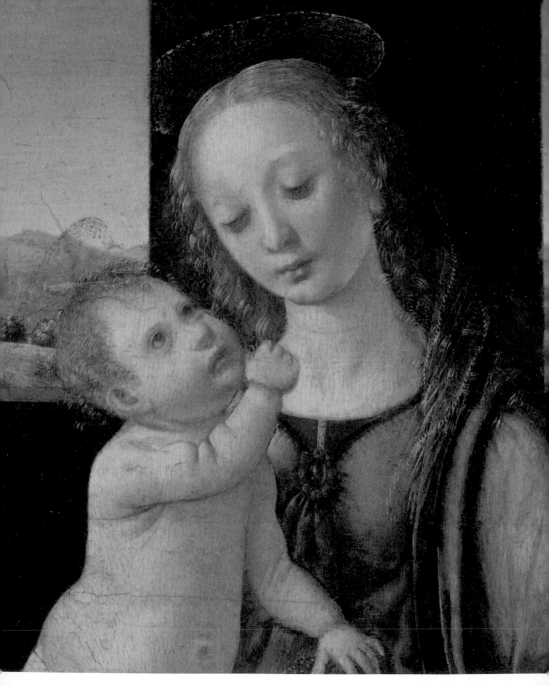

Painted around 1470 in the workshop of Andrea del Verrocchio, the small *Madonna and Child with a Pomegranate*, also known as the *Dreyfus Madonna*, has divided scholars for more than a century as to whether it should be attributed to Lorenzo di Credi or Leonardo. In support of Leonardo are the delicacy of the Virgin's face and the interaction between mother and son, a theme to which the artist returned repeatedly in his early work. In addition, the lowered eyelids and eyebrows – the latter so fine as to be almost invisible – were a constant throughout Leonardo's career. Even the reflections of golden light on the hair and lips, closed in a barely suggested smile, were to become unmistakable distinguishing traits of the faces of women painted by Leonardo.

Madonna and Child with a Pomegranate, or the *Dreyfus Madonna* (cat. 1)

IT IS A SUNNY DAY IN EARLY SPRING. Mary can finally enjoy the mild climate in the open air, on the verandah of a Tuscan villa surrounded with greenery. She is reading in an atmosphere of well-being and elegance, an elegance underscored by the delicately carved lectern. The soundless arrival of the respectful angel causes only a pause and a slight movement of surprise. The controlled emotions are very different from the intense agitation conveyed in the Annunciations by some Florentine painters, for example Botticelli. Leonardo waxed ironical about these excesses: 'I recently saw an Angel of the Annunciation who seemed to wish to chase Our Lady from her room, with such rude movements as one might show to a most vile enemy, and Our Lady looked as though she wanted to throw herself from the window in despair.'

Annunciation (cat. 3)

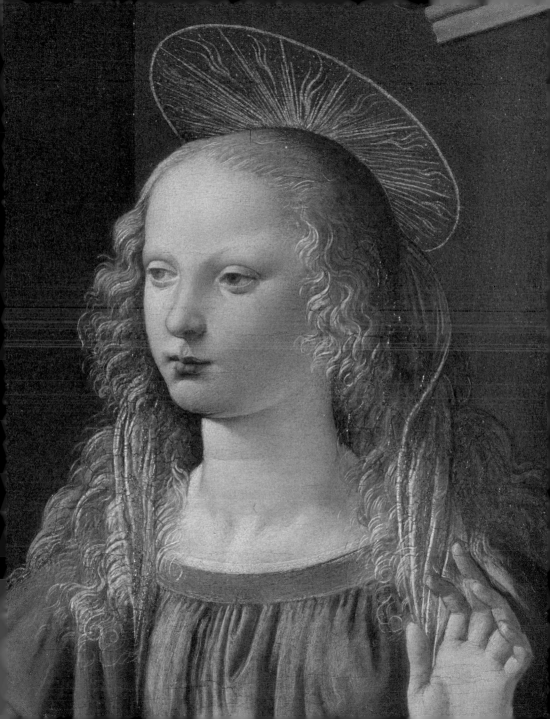

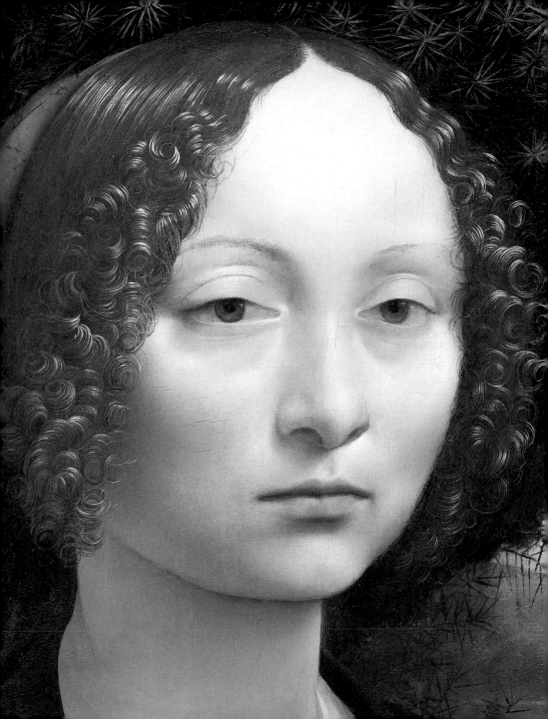

This is one of the first portraits in Florentine art to use the three-quarter view. In the workshop of Andrea del Verrocchio, Leonardo had certainly observed the effectiveness of lifelike marble portrait busts in comparison with the rigidity of the traditional profile pose found in painted portraits. The arrival in Florence of portraits executed in Flanders (such as Memling's portraits of the banker Tommaso Portinari and his wife, Maria Baroncelli) gave an additional push to making the interaction between sitter and viewer stronger and more direct. Engulfed in a natural setting, *Ginevra de' Benci* achieves all the volumetric presence of a sculpture but is further enhanced by the effect of colour. The sitter's large, deep, dark eyes under partly lowered eyelids stand out against her pallid, almost alabaster face, while the blonde reflections of her hair capture the light of the sun.

Portrait of Ginevra de' Benci (cat. 4)

HERE, FOR ONCE, LEONARDO PAINTED AN ELABORATE HAIRDO, with braids and veils similar to those worn by the ladies in Pollaiolo's paintings. But the pure, full face of the Madonna, still an adolescent, unmistakably displays the features Leonardo preferred: the downward gaze, the fine eyebrows and the wide forehead emphasized by the parting in the centre. The window opens on to a mountainous landscape, providing an effective contrast with the interior of the darkened room. Leonardo liked contrasts of dark and light, and even recommended painting studio walls black or working in a courtyard darkened by heavy drapery.

Madonna of the Carnation (cat. 6)

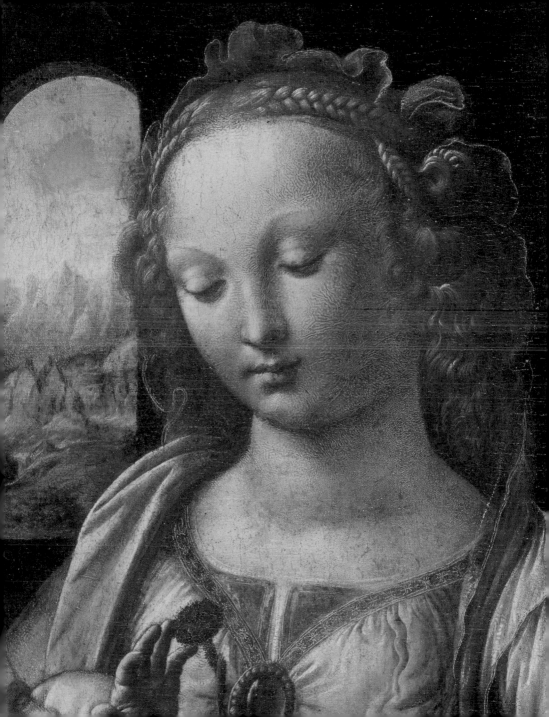

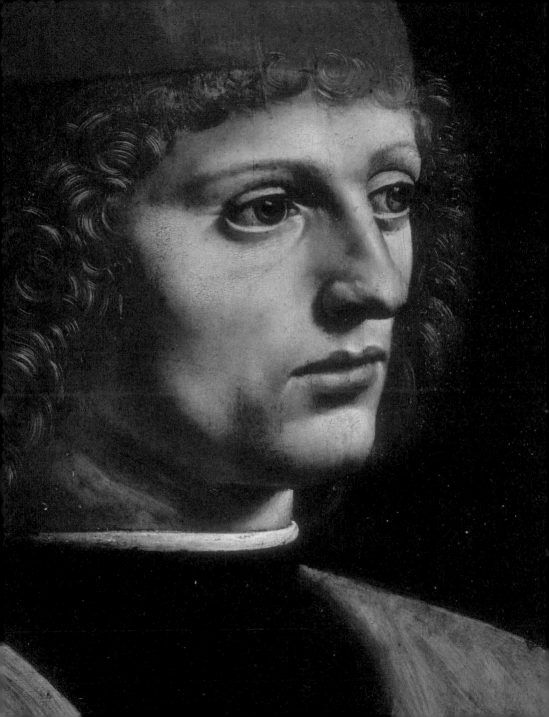

THIS IS THE ONLY PANEL PAINTING BY LEONARDO that remained in Milan. Unlike the landscape setting in the *Portrait of Ginevra de' Benci*, it has a neutral background and direct side lighting, which imparts a strong chiaroscuro effect. Portrait studies are a fundamental feature of Leonardo's art, the field in which he conducted his most persistent investigation of the 'movements of the soul' – the inner impulses conveyed by pose, facial expression and bodily stance. The intelligent, inspired face of this musician stands out strongly from the dark background. The blond curls are painted with the care of a miniaturist. The more hastily brushed red cap and clothing are the work of pupils.

Portrait of a Musician (cat. 12)

THE BEAUTIFUL YOUNG GIRL looks towards an unseen interlocutor. She slowly turns her intelligent eyes and hints at a smile, satisfied and aware of her own elegance, complete master of herself. Her hands caress the animal's soft fur; her shoulders rotate slightly. Her energy presents a perfect correspondence between the 'movements of the soul' and of the body. This portrait became famous as soon as it was painted. The court poet Bernardo Bellincioni wrote a sonnet about it that, while undistinguished on the whole, has a line that effectively describes the woman's pose: 'He has her listen, not speak'. Isabella d'Este, the marchesa of Mantua, asked her brother-in-law the duke of Milan for permission to keep the painting for a month, so local portrait painters could draw inspiration from it. Then, this masterpiece mysteriously disappeared without a trace for nearly three centuries, until it reappeared in the collection of Prince Czartoryski in Kraków.

pp. 150-51

THIS IS ANOTHER FINE PORTRAIT PAINTED AT THE SFORZA COURT, which was soon to enter the French royal collection. The alternative title derives from a former erroneous identification of the sitter as a farrier's daughter who was the mistress of King Francis I of France. The word *ferronnière* later came to refer to a small chain and pendant encircling the forehead that holds a hairdo in place, exactly as in this portrait. The sitter here is probably Lucrezia Crivelli, one of the young women who graced the court of Ludovico il Moro. The fairly usual placement of the head and upper body against a neutral dark background derives intense vitality from the young woman's charged and sympathetic facial expression and the accentuated rotation. The famous detail of the cheek's reflection of the red clothing is evidence of the meticulous attention Leonardo paid to effects of light and colour. The lady does not look towards us but almost seems to urge us to move to the side, changing position in order to meet her eyes.

Lady with an Ermine (cat. 13)
pp. 150-51 *Portrait of a Lady*, called *La Belle Ferronnière* (cat. 15)

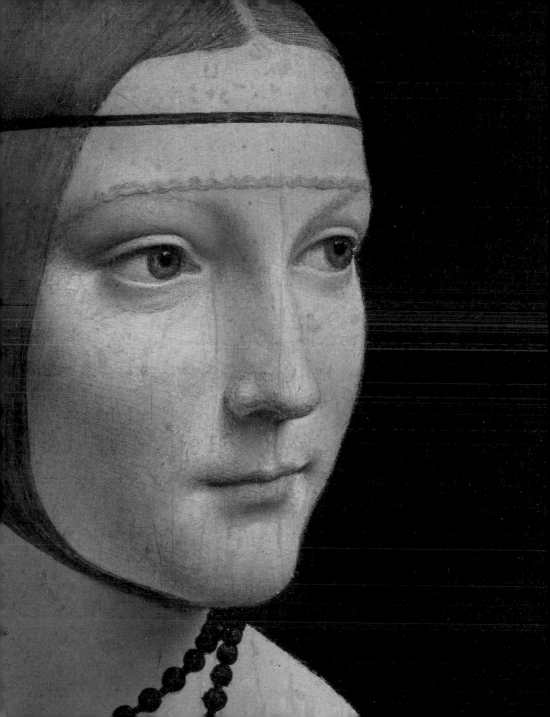

ELATED BUT ALSO PERHAPS DERISIVE, infinitely imitated, stolen then recovered, poorly conserved and still awaiting a complicated restoration, enigmatic in expression, ambiguous in pose, controversial as to the identification of the sitter and the exact geographical location, used in all manner of outlandish gift-store items and advertising, the *Mona Lisa* is probably the most famous painting in the world, and yet it still excites new emotions. Once again, Leonardo worked on the image over an extended period of years, keeping open the possibility of retouching it repeatedly and taking it with him from Florence to Milan and ultimately to France. The result of this long working-out is a fluid and elusive portrait in which the sitter's personality remains intangible.

Portrait of Lisa Gherardini, called the *Mona Lisa* or *La Gioconda* (cat. 18)

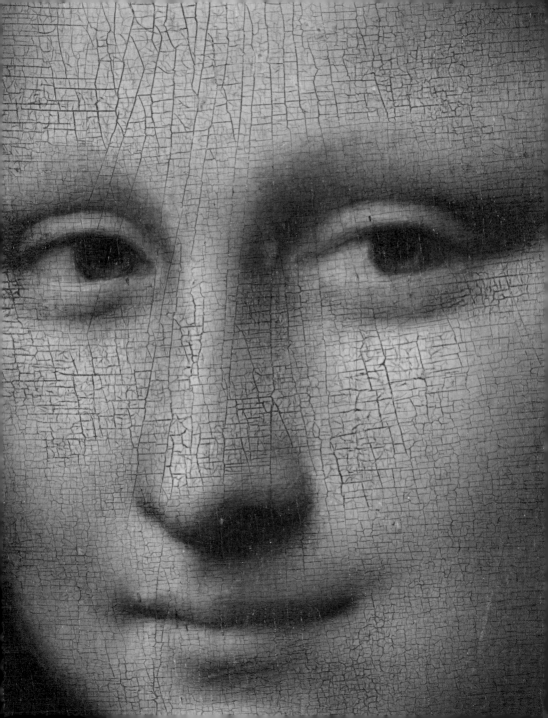

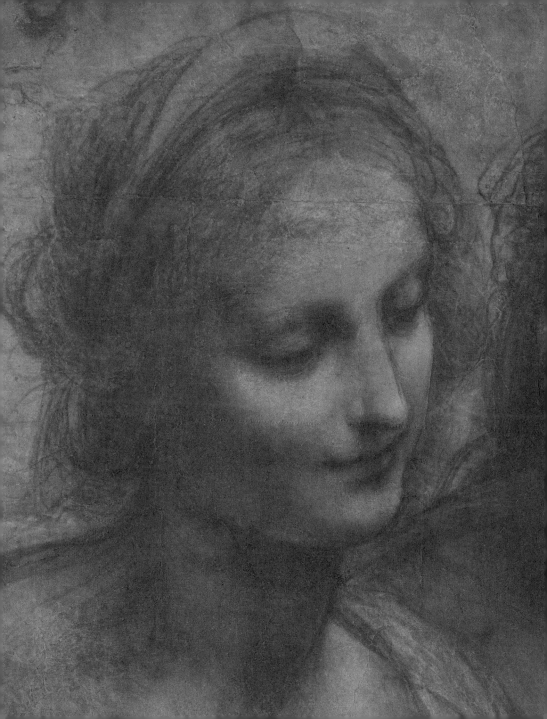

LEONARDO RETURNED TO FLORENCE in August 1500 at the age of almost fifty. He showed up in his native town with a masterpiece: the preparatory cartoon for a painting of the Virgin with St Anne and the Christ Child. A rare and invaluable document on Leonardo's work method, the cartoon represents the last stage of drawing before executing the painting in oil. In this case, however, between the working-out of the preparatory drawing and the subsequent transposition into paint, Leonardo radically altered the arrangement of the group. He spent more than ten years in research and making changes and retouches to the depiction of St Anne with the Madonna on her lap and the Infant Jesus. With no direct relation to the painting that is today in the Louvre, the cartoon is considered to be a pivotal stage in Leonardo's art, an important junction between the end of the first Milanese period and his important stay in Florence. Midway between drawing and painting (the chiaroscuro is actually in tempera over a charcoal base), the cartoon offers radical innovations that met with enthusiastic admiration from artists and the public. The figures form a single block while maintaining an extraordinary individual psychological intensity, almost an echo of the Apostles in *The Last Supper* in Milan. The graphic style heightens the vibrations of the hazy atmospheric sfumato and the gradual transitions between shadow and light, yet without enclosing the figures within strict contour lines.

Virgin and Child with St Anne and St John the Baptist
('Burlington House Cartoon') (cat. 17)

THE RAVAGES OF TIME AND OLD RESTORATIONS have obscured the gaze of the *Salvator Mundi*, a controversial but interesting painting whose sale at auction in November 2017 at Christie's New York headquarters yielded the record figure of 450 million dollars – an impressive sum that subsequently sparked discussion about the authorship of the work, which will be exhibited at the home of the Louvre in the Arab Emirates, in Abu Dhabi. Prevailing scholarly opinion now leans towards an attribution to Leonardo, taking into account the painting's poor state of conservation, which includes the panel having split into two vertically and subsequently been put back together.

Salvator Mundi (cat. 21)

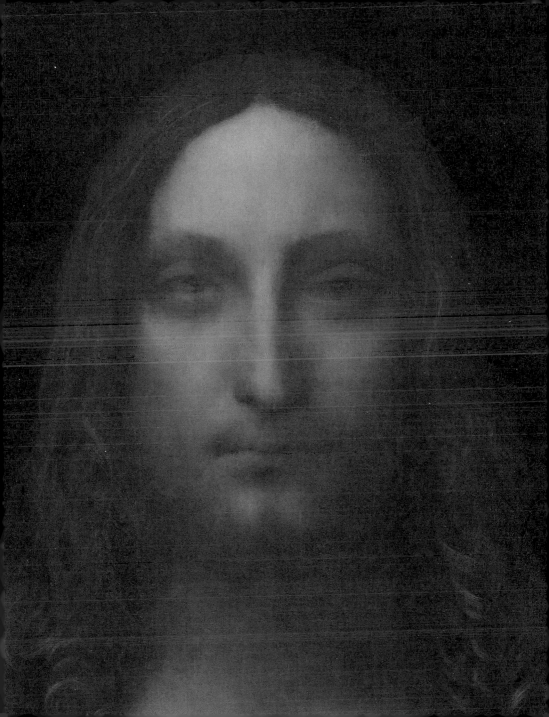

Smiles

AN ENIGMATIC, seductive smile surfaces in the features of many of Leonardo's figures. For years, countless artists sought to reproduce this intangible facial expression, but none succeeded. On the contrary, among the repetitive replicas by immediate followers and imitators, the 'Leonardo smile' too often became forced, unnatural, stereotyped. An extraordinarily innovative approach to interpreting the face and the psyche almost became a hackneyed commonplace. *Mona Lisa Smile* is even the title of a movie starring Julia Roberts as a vivacious art history teacher at an exclusive private girls' school in conservative 1950s America.

Leonardo was aware of the turning point he was initiating in the history of the portrait. As Giorgio Vasari wrote, Leonardo wanted to 'remove the melancholy expression often imparted by painters to the likenesses they take', the traditional stern seriousness that was considered an indispensable sign of nobility and that, as a young man, Leonardo himself had upheld in his revolutionary *Portrait of Ginevra de' Benci*. Also, according to Vasari, to obtain the relaxed expression of the *Mona Lisa* the master called upon musicians and jesters to entertain the sitter as she posed. Not long after that, Titian would ask his portrait clients not to sit still, but to move and talk freely.

The theme of the smile is not restricted to portraiture but extends into religious painting as well, culminating in the allusive *St John the Baptist*, probably the master's last painting. The natural smiling serenity of the *Virgin of the Rocks* is an effect that Leonardo prepared carefully, even with a touch of polemic in regard to the Florentine art of his time. The arrival of Flemish masterpieces from Bruges, such as the Portinari Triptych by Hugo van der Goes, had captured Tuscan painters' attention, particularly the refined details and analytic description of the clothing and elaborate hairdos. Leonardo, however, retained their simple 'grace' to attract 'admiration and delight'. Addressing an imaginary painter, he said, 'Do you not see that among human beauties it is the beautiful faces that stop passers-by and not the richness of their ornaments? And this I say to you who adorn your figures with gold and other rich ornaments.'

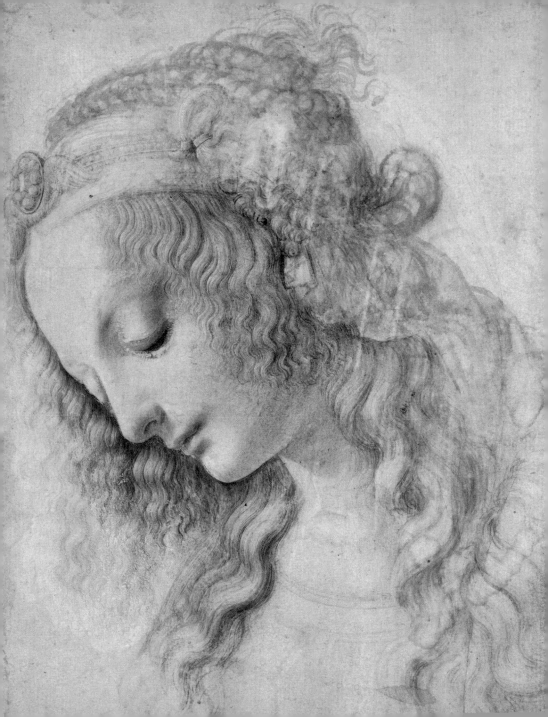

THIS ENCHANTING DRAWING, executed in a particularly intricate technique, is now unanimously considered by scholars to be one of Leonardo's early masterpieces. It is dated between 1468 (when Leonardo was barely sixteen and had just entered Verrocchio's workshop) and 1475. In any case, it is one of the first appearances of the proverbial Leonardo smile, which soon reappeared in the Louvre's small *Annunciation*. Leonardo effectively expressed the concept of the 'grace' to be conferred upon faces: 'It seems to me to be no small charm in a painter when he gives his figures a pleasing air, and this grace, if he have it not by nature, he may acquire by incidental study in this way: look about you and take the best parts of many beautiful faces, of which the beauty is confirmed ... by public fame.'

Study of a Woman's Face (cat. 23)

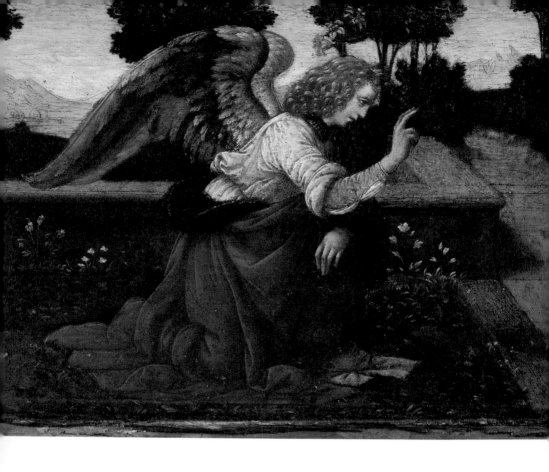

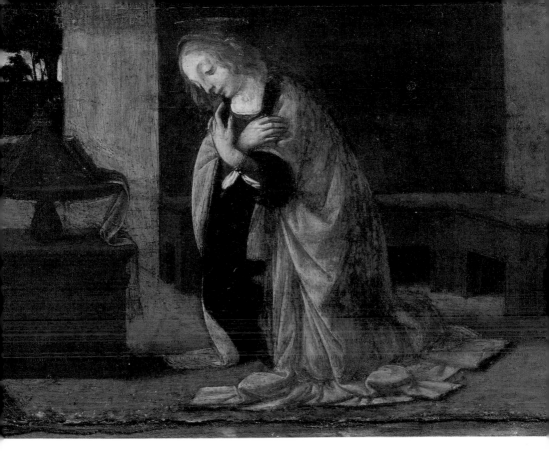

LEONARDO REDUCED THE SYMBOLS IN THIS SCENE TO A MINIMUM: apparitions of God the Father and the Holy Ghost are absent, the haloes are simple circles of gold, and the lily (sign of Mary's purity) brought by the angel is all but hidden. In this panel, which at one time was part of the predella of the altarpiece painted by Lorenzo di Credi for Pistoia Cathedral, Leonardo adopted one of the most frequent poses for Mary. She kneels, crossing her arms over her breast in a sign of devoted acceptance as she utters the words *Ecce ancilla Domini* ('Behold the handmaiden of the Lord'). However, Leonardo has given the Virgin a joyous expression, interpreting to perfection the meaning of the Gospel passage and Mary's attitude not as meekly submissive but as a profound sense of inner rejoicing.

Annunciation (cat. 7)

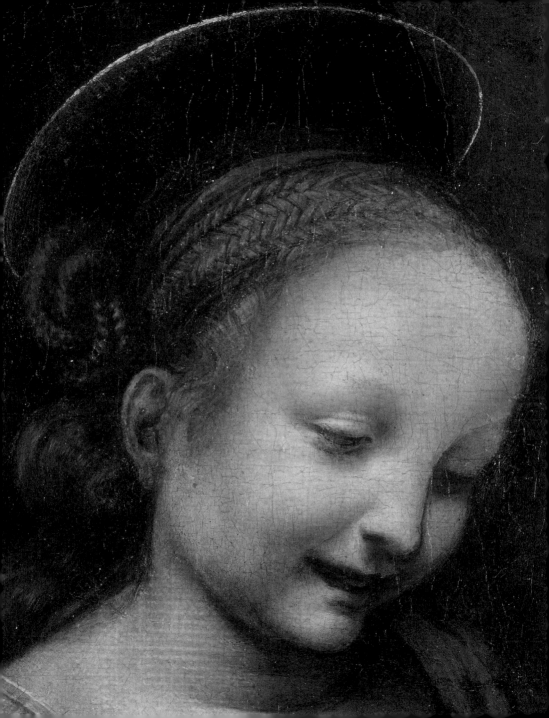

IN THE HISTORY OF THE CRITICAL LITERATURE ON LEONARDO, the *Benois Madonna* has had detractors who have criticized, among other things, the young woman's excessively rounded forehead. However, it was fashionable in fifteenth-century Florence for young women to shave their foreheads to make them look broader. Far more numerous are the commentators who have admired the absorbing spontaneity of the young Mary, who smiles as she plays with the Infant Jesus. As in the contemporary *Madonna of the Carnation* in Munich, Leonardo depicts a complicated hairdo with braided tresses gathered at the nape of the neck, which contrasts with the woman's fresh and natural 'soap and water' expression.

Madonna of the Flower or *Benois Madonna* (cat. 8)

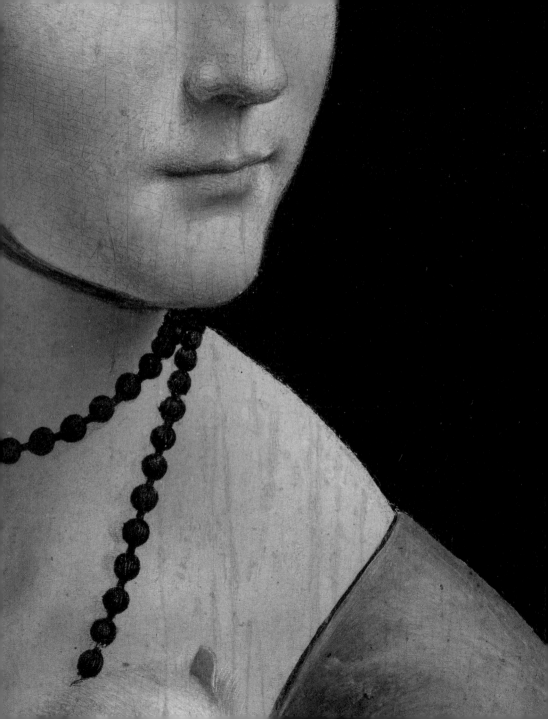

Can Cecilia Gallerani's facial expression really be called a smile? Or should we distinguish the crease of the straight, narrow lips from the inner light emitted by the eyes, from the expressive movement of the whole person, who seems to be turned inward upon herself? At the time of this portrait, Cecilia was the young lover of Ludovico il Moro. Leonardo has portrayed her as having considerable maturity for her age, reflected in a full sense of emotional and intellectual awareness. As in the other portraits he painted at the Sforza court, Leonardo made use of a dark, neutral background, intensifying the role of the light and shadow – a formula that was immediately taken up by painters active in Milan and that would continue to exert a strong fascination throughout the sixteenth century, even becoming a reference for Caravaggio's training.

Lady with an Ermine (cat. 13)

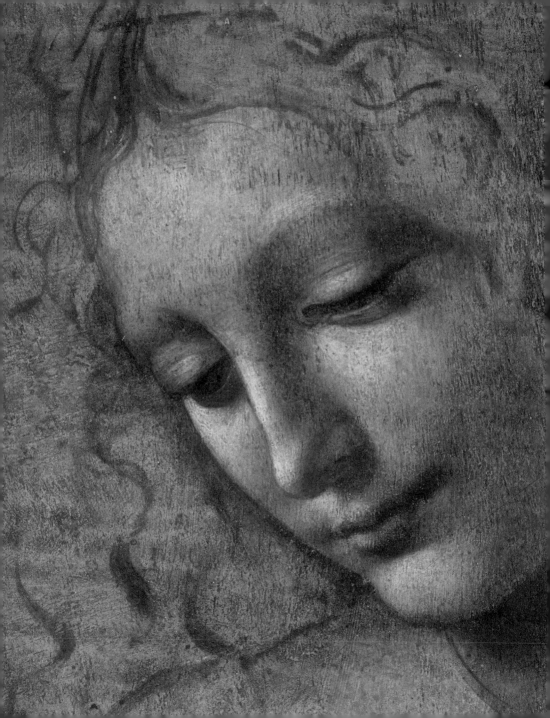

THE WORK PRESERVED IN PARMA is an unfinished painting, not a preparatory drawing. It is probably a free study from life, although it could be connected with the mythological painting *Leda and the Swan*, for which Leonardo made many studies, but which was actually executed by his pupils. The smile, downcast eyes and regular features exemplify the female features typically depicted by Leonardo and reused countless times by sixteenth-century painters. The nickname *Scapigliata* ('dishevelled head') derives from the lively, loose hair with rebellious locks that frame the young woman's sweet face. Leonardo did not like overly elaborate hairdos, make-up or the use of lacquer to fix the hair in place: 'Leave off affected curls and hair styles ... Depict hair which an imaginary wind causes to play about youthful faces, and adorn the heads you paint with curling locks of various kinds, and do not do like those who smear them with glue and make the faces appear as if they were glazed.'

Head of a Woman, called *La Scapigliata* (cat. 20)

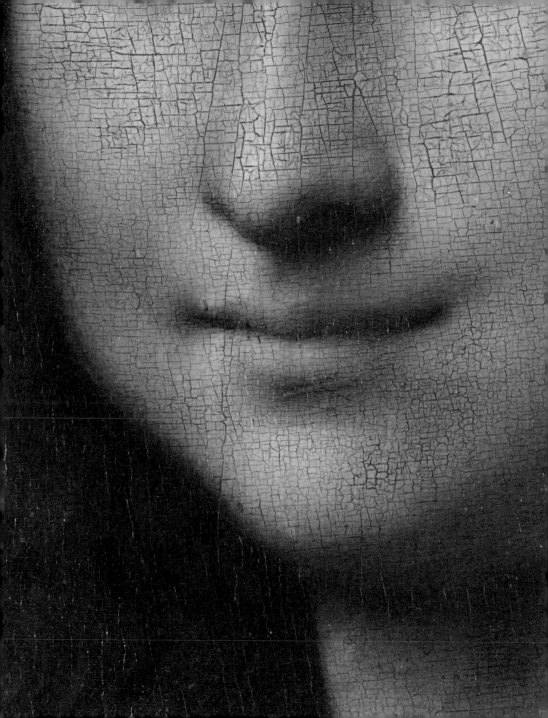

IN FLORENCE AROUND 1503 LEONARDO BEGAN TO PAINT THE PORTRAIT of a woman identified as Monna (a shortened form of *madonna*, 'madam') Lisa, the wife of Francesco del Giocondo. The artist kept it with him during his successive stays in Milan and France so that over the years he could retouch it and alter it. This is how the painting's history is usually presented, but we must be prudent: the most famous painting in the world is still pervaded with mystery. Vasari gives a precise description of it, but it is quite unlikely that he ever saw the original. Furthermore, not everyone agrees that the sitter is the wife of a Florentine merchant. Some think she is a lover of Giuliano de' Medici, based on an observation of Antonio de Beatis, secretary to the cardinal of Aragon, who saw *La Gioconda* in France in 1571. There is no end to the places that claim to be the 'true' landscape of the background. And opinions as to its date are widely divergent. In any case, the execution of the work took place over many years, with an infinite series of retouches, changes and superimpositions. From the beginning, the portrait must have appeared both seductive and disturbing, enveloped in the humid quiver of a misty landscape and grazed by the hint of a smile that makes the 'movement' of this woman's soul elusive. The natural setting, loaded with deeply innovative tonal and psychological values, is in complete harmony with the blurred, changeable background and the still-tentative emergence of a feeling, a personality.

Portrait of Lisa Gherardini, called the *Mona Lisa* or *La Gioconda* (cat. 18)

HYPERCRITICAL, PERFECTIONIST, NEVER SATISFIED ONCE and for all with an outcome, Leonardo was completely unconcerned with how long it might take him to bring a painting to completion. In an outburst that seems almost to anticipate Descartes, he asserted that 'the painter who does not doubt acquires little' and urged his colleagues never to be content, but to continue to change, improve and correct their works. The 'Burlington House Cartoon' is a decisive turning point in the long genesis of the *Virgin and Child with St Anne*, a typical example of Leonardo's protracted creative process. The image took form over time through the progressive shaping of the figures in a natural setting that gradually clears out and brightens. And, once again, the unmistakable smile appears, a facial expression filled with love of life, faith in the future, a full awareness of the spirit and feelings.

Virgin and Child with St Anne and St John the Baptist
('Burlington House Cartoon') (cat. 17)

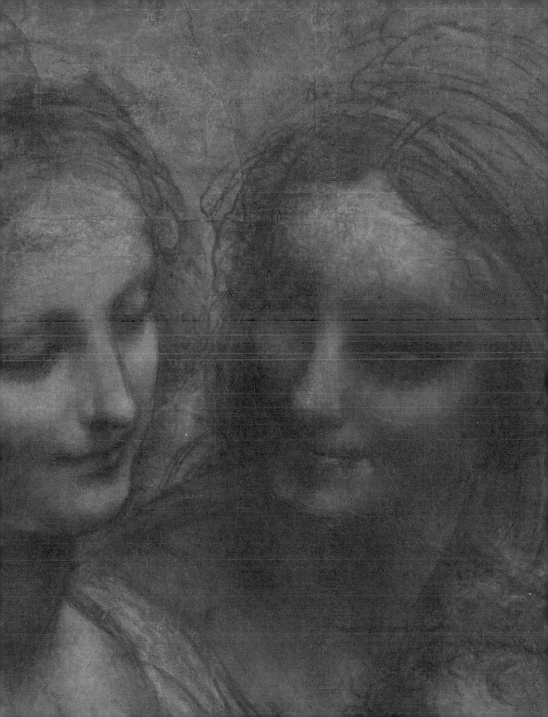

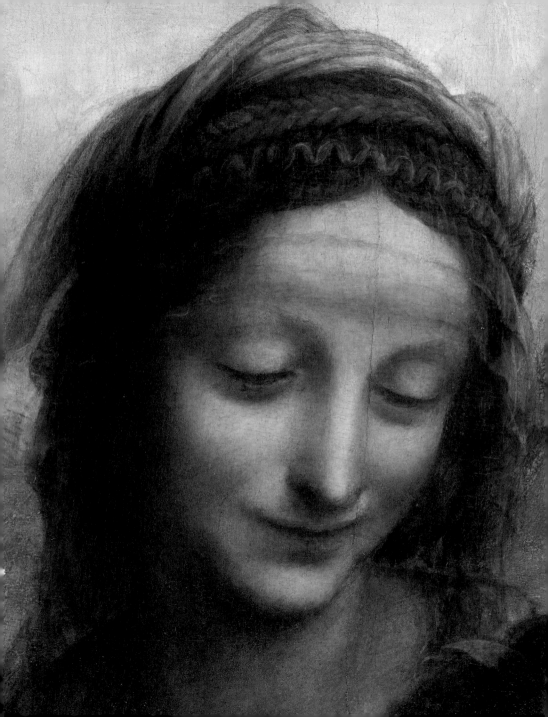

THE FINAL PAINTED VERSION OF THE *VIRGIN AND CHILD WITH ST ANNE* was recently cleaned by the conservator Cinzia Pasquali - a prelude to a long-awaited treatment for the most famous of Leonardo's paintings, the *Mona Lisa* in the Louvre. The renewed transparency and clarity of the light and colours emphasize even more the affectionate rapport among the three figures, underscored by the smiles they exchange. With serene gentleness, the two women turn towards the Infant, placed at the ideal centre of the composition even though this is towards the lower right corner. It is a full demonstration of Leonardo's injunction to represent 'mirth with various acts of laughter, and describe the cause of laughter'.

Virgin and Child with St Anne (cat. 19)

SITTING IN ANNE'S LAP AND BENDING FORWARD to support the little Jesus, Mary is the key figure in the concentrated group of gestures, gazes and smiles around which the *Virgin and Child with St Anne* is constructed. Once again, the work had a very long genesis: besides the cartoon in London, a large number of drawings and sketches are known that relate either to the entire group of figures or to single aspects of the composition, such as the drapery and the pose of the Infant Jesus. But the final effect is nonetheless spontaneous and as natural as a placid family scene. In comparison with Leonardo's previous works, the hairdos and clothing of the two women are quite simple, as if to demonstrate the precept 'In narrative paintings, never give your figures and other bodies so many ornaments that they obscure the figures' form and pose.'

Virgin and Child with St Anne (cat. 19)

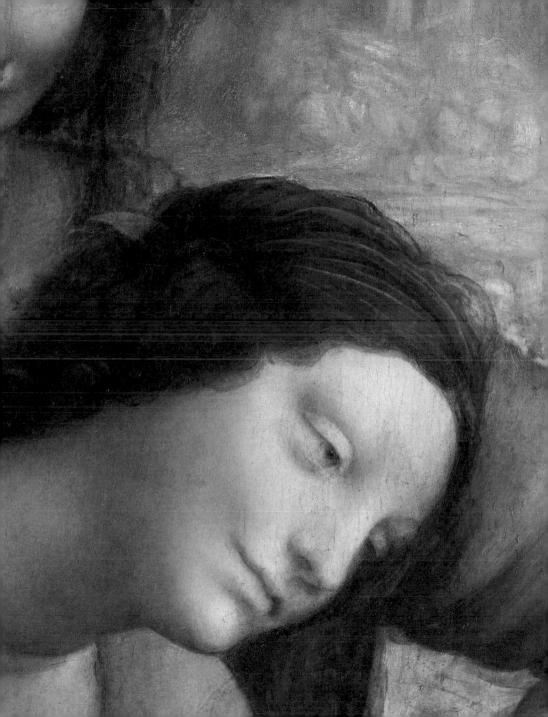

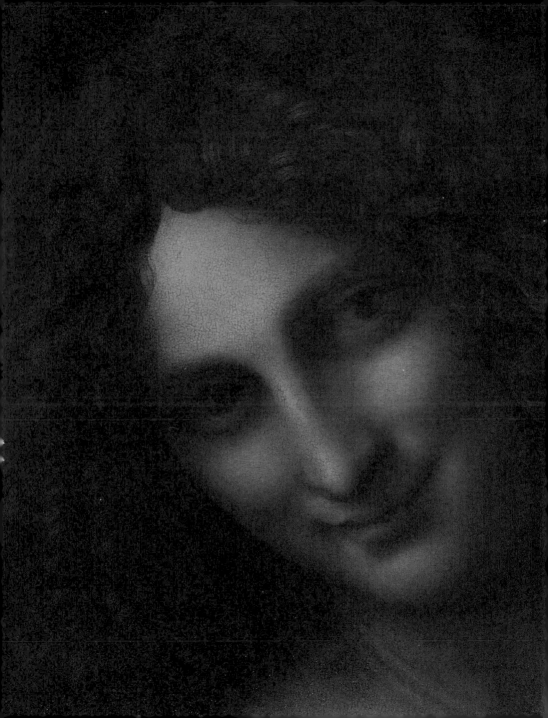

Perhaps begun in Florence at the same time as the *Mona Lisa*, this painting is another of those that followed Leonardo through his various moves, eventually ending up in France. The master kept on retouching it extensively for another decade until, in the last years of his life, his health prevented him from painting. There is a strong interaction between the viewer and the smiling saint, who, leaning slightly forwards, looks squarely towards the viewer. The hazy sfumato effect softly models the face and limbs of the figure that emerges into the light from the shadowy background. This close-up detail shows how meticulously Leonardo depicted the intricate curls, which he likened to eddies in the water. It has been suggested that the sitter is Leonardo's young pupil Gian Giacomo Caprotti, nicknamed Salaì, to whom the artist bequeathed the paintings he took with him to France.

St John the Baptist (cat. 22)

Technology

AMONG THE MORE THAN 1,100 LEAVES in the monumental Codex Atlanticus – the huge mass of Leonardo's notes and insights now at the Biblioteca Ambrosiana in Milan – there is a transcription of the letter of introduction the thirty-year-old Florentine sent to the duke of Milan, Ludovico il Moro. Leonardo lists his qualifications in ten numbered paragraphs, and only in the last does he hint at his artistic ability. The first nine describe his competence in military, civil and hydraulic engineering. After presenting himself as an engineer – 'I have plans for extremely light and strong bridges, adapted to be easily portable' – he proceeds to list his inventions and solutions.

For his whole life, Leonardo continued studying and designing military devices, spinning machines, metallurgical apparatus, excavating and earth-moving systems, equipment for dredging canals and building locks to control the flow of rivers, instruments enabling humans to fly and survive under water, and fantastically complicated perpetual-motion machines, among other things. His aptitude for technology originated in the years he spent as an apprentice in the Florentine workshop of Andrea del Verrocchio. Leonardo would never forget the casting of a large gilt-bronze sphere to be hoisted to the pinnacle of Brunelleschi's dome, an undertaking successfully carried out by Verrocchio in 1471. The cranes and machinery Brunelleschi used in the imposing construction of Florence's cathedral were still in operation, and Leonardo made detailed drawings of this equipment, which obviously fascinated him. In the years following these preliminary experiences in Florence, Leonardo developed projects for an extraordinary number of 'machines' aimed at surmounting humankind's natural limits.

While in the study of anatomy and natural science Leonardo greatly surpassed the culture of his time, in regard to technology he was in step with fifteenth-century mechanics. He knew the treatises of Valturio, Mariano di Jacopo, called Il Taccola ('the Jackdaw'), and Francesco di Giorgio Martini, a polymath artist from Siena whom Leonardo had met in Milan on the occasion of a tour of inspection related to the execution of the dome of the cathedral.

The sometimes unrealistic 'inventions' attributable to Leonardo are less innovative than his attention to the graphic phase of planning and presentation. In some instances, he drew the various parts of a machine separately, numbering them in sequence to make clear how they were to be assembled. Unlike his contemporaries, he was more concerned with how a technological implement functioned than with its external appearance.

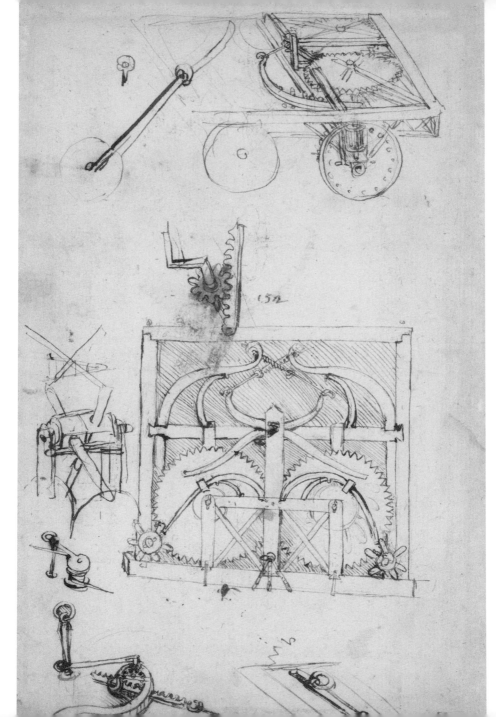

ONE OF LEONARDO'S MOST FAMOUS and most discussed technical drawings is considered to be an early work, from the first Florentine period. It is sometimes claimed to represent an 'ancestor' of the automobile, but this is overly optimistic. It is essentially a system of cogwheels – activated by large leaf springs stretched by pulleys (illustrated separately) – that gives forward momentum to a four-wheel handcart, with a fifth wheel for steering. Leonardo also designed a mechanism for stretching the springs. The accuracy of the drawing made it feasible to build a working model, which is at the Museo Nazionale Scienza e Tecnologia in Milan. The vehicle Leonardo projected, one of his first 'inventions', cannot be considered road-worthy. The thrust of the spring-activated wheels would carry it only a few metres. If anything, it might be employed as a theatrical prop. On the other hand, the steering wheel is of considerable interest. Leonardo conceived an innovative differential transmission system that follows a curve's radius and prevents the cart from tipping over.

Self-propelled cart (cat. 25)

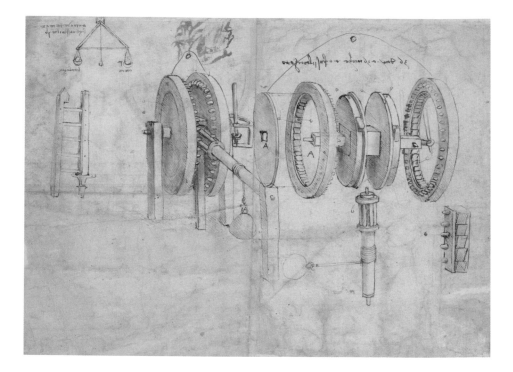

As a youth, Leonardo must have avidly observed the architectural and engineering activity at the building site of the cathedral of Santa Maria del Fiore. The cranes, winches and hoists Brunelleschi used for the construction of the dome were still present, and Andrea del Verrocchio had been called upon to cast a bronze sphere and hoist it more than a hundred metres to the pinnacle. This technical drawing presents apparatus for lifting on building sites. Its particular interest lies in the innovative graphic rendering. Here, Leonardo has created an 'exploded view': the components, depicted individually in the order they are to be assembled, are labelled with a letter that is carried over into the instructions. This method is still used in technical manuals.

Two-wheel winch (cat. 26)

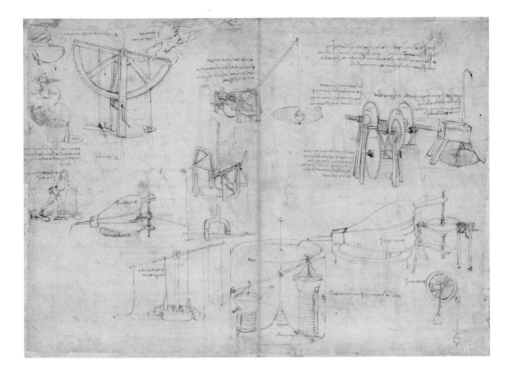

PERHAPS EXECUTED IN FLORENCE shortly before Leonardo moved to Milan, this sheet is devoted to one of his most typical and persistent areas of investigation: means of breathing and walking under water. In addition to plans for siphons, bellows and compressors to pump air, near the upper left edge the large drawing shows two human figures: one is gliding across the water's surface on two cork floats, keeping balance with poles, as in cross-country skiing and Nordic walking; the other is breathing through a snorkel. Research into water was characteristic of Leonardo's career as a naturalist, a technician and a painter, and he was perfectly aware of the military implications of controlling water. On a folio in the Codex Leicester (today in the collection of Bill Gates in Seattle), besides insisting on the need for people to learn to swim and recommending the use of ordinary cane tubes for breathing under water, Leonardo adds a significant note about plans for a submarine: 'I will not write my way of staying under water or how long I can go without eating. This I do not publish or make known owing to the worse nature of men, who would engage in killing under the sea, breaking ships from the bottom and sinking them with all the men on board.'

Figures and systems for flotation and breathing under water (cat. 27)

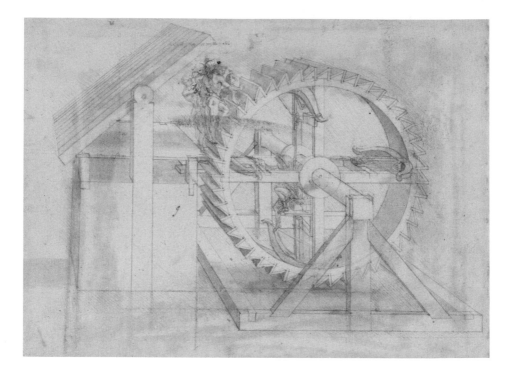

A CUMBERSOME OFFENSIVE DEVICE FOR SIEGES AND BATTLES is illustrated
in this relatively finished drawing, probably meant for presentation
to Ludovico il Moro, who was fascinated by war contraptions. At the
left, a wooden scaffold with an adjustable inclined roof serves as a
tower shielding the main artillery, which consists of a large stepped
wheel firmly planted on a large base. The mechanism is activated by a
group of soldiers who march up the steps at a regular pace, protected
by the tower's slanted roof. Another soldier, seated in the centre of
the wheel, looks through an opening and shoots arrows from four
crossbows attached to the wheel's spokes. It is one of many examples
of war machines planned by Leonardo for repeat firing of arrows, darts
and explosive projectiles from gun barrels. The Codex Atlanticus also
illustrates a smaller wheel, with sixteen crossbows that fire repeatedly
as they are reloaded by means of a special gear wheel with rods.

Repeat firing mechanism for a crossbow (cat. 28)

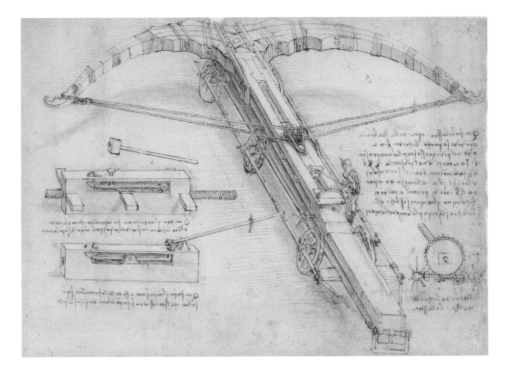

IN HIS LETTER OF INTRODUCTION TO LUDOVICO IL MORO, Leonardo demonstrated that he was well aware of the important psychological effect of new weapons that appear in the battlefield. Speaking of his mortars, he emphasized that, in addition to the projectiles themselves, 'their smoke causes great terror to the enemy, to his great detriment and confusion'. Some of the war machines Leonardo conceived are definitely 'impossible' and obviously could not be employed on the battlefield. But the drawings that depict them are only partly technical and are meant more to arouse surprise, fear and consternation. This applies, for example, to the carts with rotating blades that literally cut the enemy to pieces or this gigantic crossbow, a sort of 'Dulle Griet' (the huge cannon used in the late sixteenth-century Wars of Religion) or 'Big Bertha' before its day. According to the drawing and explanatory legend, the bulky crossbow, mounted on three axles and three large pairs of cartwheels, would be 20 metres long and able to hurl projectiles weighing 50 kilos, with all the concomitant difficulties of transport and munitions supply. Leonardo made two further quite detailed drawings for the firing mechanism, showing how this colossal device could be set up and activated by a single soldier.

Giant crossbow (cat. 29)

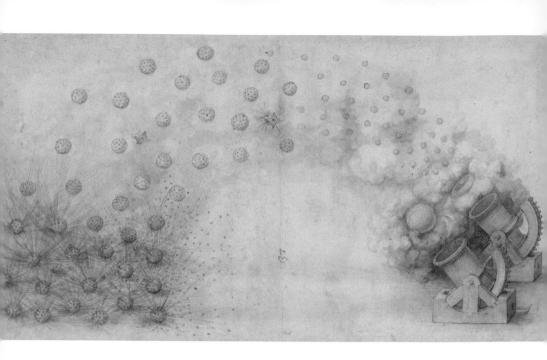

THIS DRAMATICALLY EFFECTIVE DRAWING is in harmony with Leonardo's letter of introduction to the duke of Milan, of which the Codex Atlanticus contains a transcription in another hand (the original has been lost).

In a cloud of smoke, two large mortars spew a parabola of exploding projectiles of various sizes and shapes, some of which break up into smaller metal balls when they hit the ground. It is one of the most accurate of Leonardo's drawings in the entire 1,100-folio corpus of the Codex Atlanticus. The late Renaissance sculptor Pompeo Leoni, who inherited Leonardo's papers, chose it for the first page of the collection. The drawing precisely analyses the structure of the mortars, with their solid wooden base and cogwheels that adjust the firing angle. The viewer's eye irresistibly follows the bombs' trajectory, depicted as a slow-motion sequence.

Mortars with exploding projectiles (cat. 31)

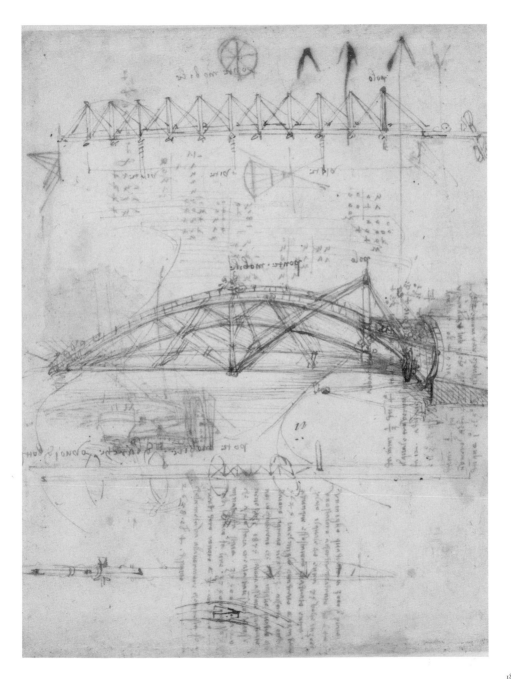

LEONARDO ASSURED LUDOVICO IL MORO that he could build bridges 'adapted to be easily portable', and the codices do in fact include various plans for portable bridges. This folio shows three versions. The one at the top is supported on the riverbed at three points, while the one at the bottom is supported by boats or floating barrels. The most elaborate and interesting project is the one in the middle, for a bridge with a parabolic span that can rotate on the pivot it is attached to. It is moved with hoists and ropes, a counterweight making it easier to manoeuvre and keeping the structure balanced until it comes to rest on the opposite shore. The drawing includes the small figure of a horseman crossing the bridge. Leonardo's fame as a bridge designer spread to other lands. In 1502, through the Turkish ambassador in Rome, the Ottoman sultan Bayezid II requested that he design a bridge connecting Galata and Istanbul. The spectacular project for a 220-metre single-arch span was not built, but, interestingly, in 2001 Leonardo's study was used for constructing a bridge in Norway, not far from Oslo.

p. 189 *Study of swing bridges* (cat. 32)

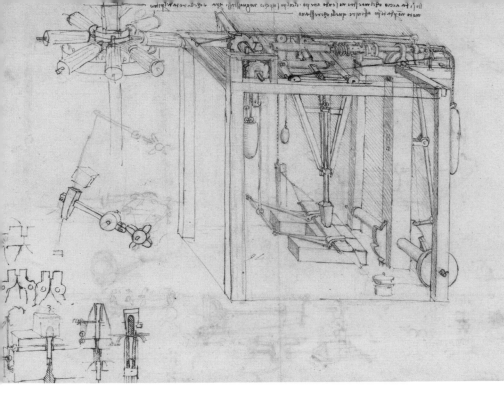

In the 1490s, at the same time as Leonardo was working on *The Last Supper*, he drew various plans related to the economy of the Duchy of Milan: locks and excavating machines for canals, textile-manufacturing equipment, and devices like these, meant to facilitate the work of goldsmiths employed in beating gold into thin sheets and foil. The drawing is particularly accurate in its depiction of a system of weights and counterweights that guarantees the regular cadence of the punch's impact against the gold plate. Although it is not certain that this 'invention' is by Leonardo, it improves upon the complicated but efficient machine he may have had the opportunity to observe in use in Milan workshops. The gold laminae produced by machines like this were not for jewellery but were mainly used as appliqués and decorations for the lavish costumes worn at court.

Gold-beating machine (cat. 38)

This sheet is inscribed 'Thursday, 6 November', which provides a reliable means of dating it, for we know that 6 November fell on Thursday in 1494. At the same time Leonardo was starting to work on *The Last Supper*, he was also trying to create a model of beating wings that would enable humans to fly. During that period, he was residing next to the cathedral, in an apartment in the old court of the Viscontis, which later became the Royal Palace. One of the rooms was used as a laboratory, and his research on beating wings led to the execution of a prototype, as well as to the realization that for a human body to rise into the air required a wing too large for one person to manoeuvre. Nonetheless, this drawing is not the summary sketch of a vague notion but a detailed plan that could be executed. Leonardo was very possessive of it, so he increased the difficulty of reading his 'backwards' handwriting by incorporating anagrams.

Close attention to the wing structure and flight of birds is obvious in all of Leonardo's studies of beating wings. He constantly sought ideas by observing nature, even in the least expected places: 'It should not be hard for you to stop sometimes and look into the stains of walls, or the ashes of a fire, or clouds, or mud or like places, in which, if you consider them well, you may find really marvellous ideas.'

pp. 194–95

Leonardo entitled this impressive double sheet devoted to plane geometry 'The transformation of equal rectilinear surfaces into various curved surfaces'. It is a refined exercise in the intellectual interplay of graphics and mathematics. In nine rows, Leonardo drew 167 figures in semicircles and nine in circles (in the bottom row, towards the left). The point of departure is a square inscribed in a circle, according to a model by Vitruvius. In each figure, the square is broken down and transformed in such a way that within every semicircle the white surface is equal to the hatched surface. Leonardo's passion for mathematics was stimulated by contact with the Tuscan mathematician-monk Luca Pacioli, a fellow citizen of Piero della Francesca and a friend of a number of artists, who was in Milan from 1496 to 1499. With Pacioli and Bramante, Leonardo took part in discussions and exercises on mathematics and architecture, and even provided illustrations for the full and hollow regular geometric solids described in Pacioli's 1498 treatise *De Divina Proportione*.

Mechanical wing (cat. 39)
pp. 194–95 *Geometry exercises* (cat. 40)

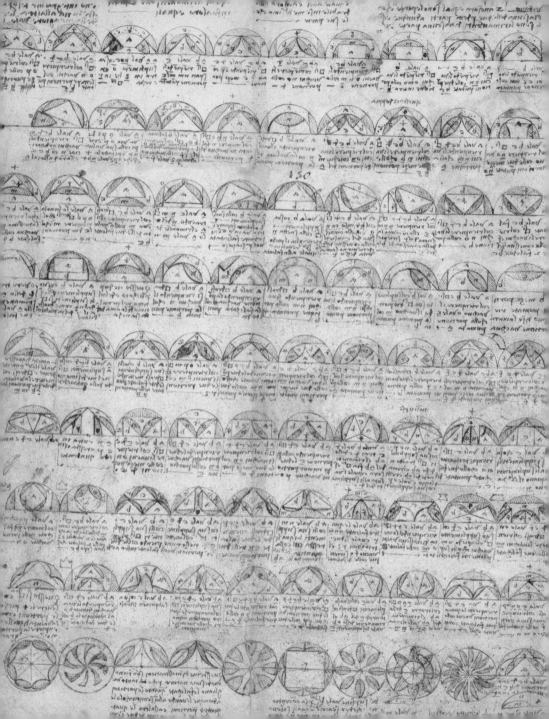

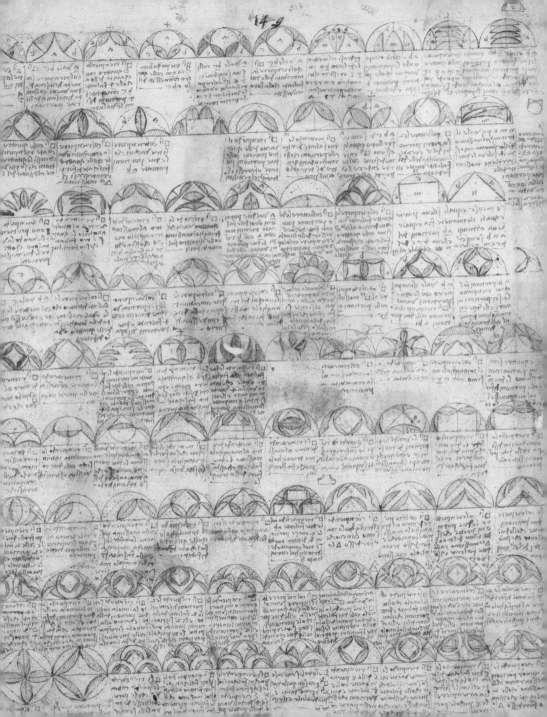

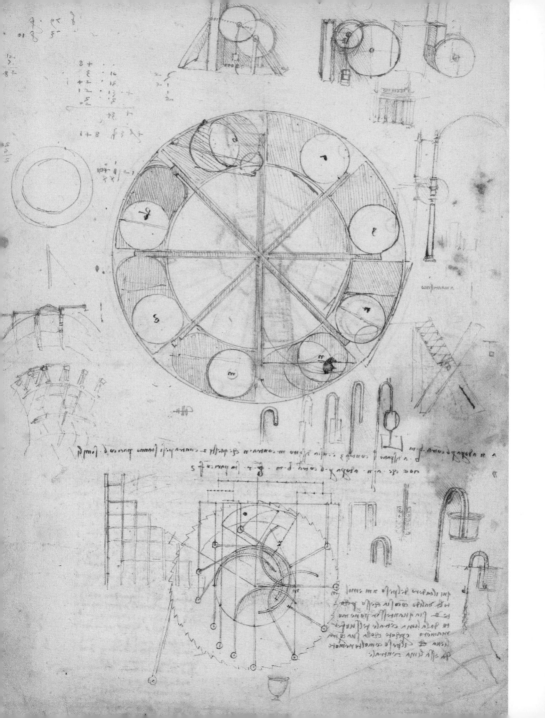

LEONARDO'S MIND REMAINED ACTIVE EVEN AT NIGHT: 'I myself have proved it to be of no small use, when in bed in the dark, to recall in my mind the external details of forms previously studied, or other noteworthy things conceived by subtle speculation; this is certainly an admirable exercise and useful for impressing things on the memory.' Perhaps it is these nocturnal meditations that gave rise to 'impossible' projects that defy the laws of nature, like this one for a perpetual-motion machine. The main drawing represents a wheel divided into eight sections. Balanced in each section is a spherical weight that, when it falls, produces a momentum that sets the wheel in motion. However, Leonardo was aware that the force of gravity cannot be overcome: 'No instrument manufactured with human genius ... can remedy this effect.'

Leonardo often reused folios several times for various annotations. This one also contains accounting notes, drawings of siphons to empty vessels and small receptacles, and, at the bottom, a project for scaffolding to be assembled into tiered viewing stands.

Perpetual-motion machine (cat. 41)

Anatomy

THE CORPUS OF ABOUT 150 DRAWINGS OF THE HUMAN BODY in the Royal Collection at Windsor represents one of the most striking facets of Leonardo da Vinci's artistic and scientific production. Their remarkable contrast with the mediocre generic illustrations in the medical treatises of the time is due not only to the tremendous difference in artistic quality but above all to Leonardo's completely new approach to observing and studying anatomy.

Medical science at that time was based essentially on the Hippocratic theory of the 'four humours', or fluids, that flowed in the human body: blood, phlegm, black bile and yellow bile. Albrecht Dürer, perhaps the only other European Renaissance artist comparable to Leonardo in draughtsmanship and the study of the natural world, is known to have adhered to this theory. But Leonardo held that 'things are much more ancient than letters': the doctrines of the past were always to be tested against direct observation, free from preconceptions.

In this spirit of investigation, Leonardo wanted to see and understand for himself how the human 'machine' functions, and the only way to go about it was by dissecting cadavers. Besides having begun to dissect animals as a child, Leonardo calculated that in his lifetime he performed no fewer than fifteen (perhaps thirty) autopsies, mainly at hospitals in Milan and Florence and at the University of Pavia, under the guidance of Marcantonio della Torre. On the other hand, to his regret he was unable to carry out anatomical dissections during his relatively unhappy time in Rome, where he moved in late 1513. Perhaps these difficulties are what prevented him from completing his treatise on anatomy, one of many projects he left unfinished.

Leonardo's research was only partly motivated by a desire for accurate artistic representation of the human figure, a desire shared by many painters and sculptors of the time. But their concern was limited mainly to the body's proportions and external appearance, or at most musculature, in order to depict movement more naturally. Leonardo was intent on delving much deeper into the mystery of life and the origin of feelings, emotions and thoughts. It is certainly not at random that Leonardo devoted so much attention to the brain, the heart and the foetus in the mother's womb – hidden features, irrelevant for artists yet crucial to an understanding of physiology.

Then again, Leonardo was keenly aware of the importance of representation. A marginal note on one of the anatomical drawings at Windsor reads, 'O writer, with what letters will you write the total figuration with such perfection as drawing gives us here?'

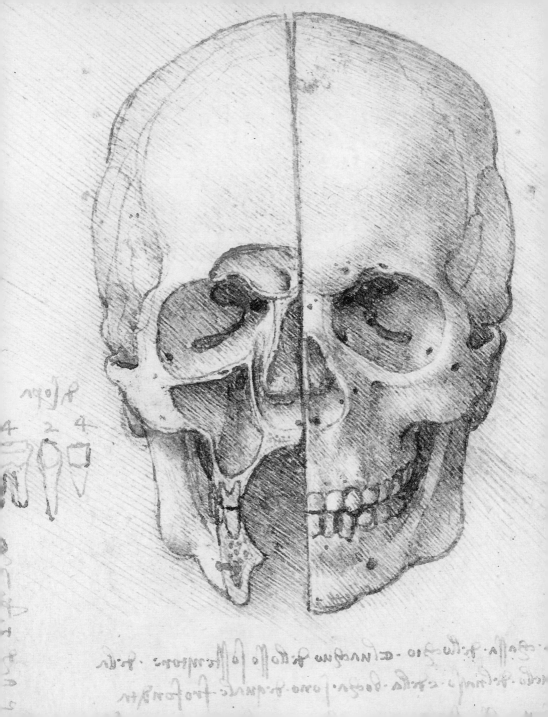

LEONARDO'S FIRST DRAWINGS OF HUMAN ANATOMY date from about 1490, when he would have had access to the modern Ospedale Maggiore in Milan, known as the Cà Granda (the 'Great House' for invalids and the poor), founded at the behest of Duke Francesco Sforza in 1456 and built by the Tuscan architect Filarete. However, at that time Leonardo had few opportunities to dissect human limbs or perform autopsies on bodies and so had to rely on research using animals. However, a drawing of a cross-section of a leg that appears to have been done from life, and various highly accurate, macabrely beautiful cranium studies date from this period. Leonardo was particularly interested in how the skull encases the brain and in the openings that nerves pass through.

Anatomical study of a skull, sagittal section, front view (cat. 34)

In this drawing, Leonardo investigates the human skull with implacably lucid precision. It is easy to understand why a painter would want to master the depiction of the skull, as it appears frequently in painting, for example in the hands of St Jerome meditating, at the foot of Christ's Cross on Calvary and in allegorical paintings that allude to the evanescence of the things of this world and warn of the final destiny of us all. But in 'opening' the bony structure of the cranium to examine what is inside, Leonardo crossed the boundary between art and science. His drawings from this period are part of a collection of notes known as Manuscript B. In a second phase that started with the dissections performed in Florence, he began a collection of more complex and ambitious drawings, known as Manuscript A.

Anatomical studies of a human skull, sagittal section, side view (cat. 35)

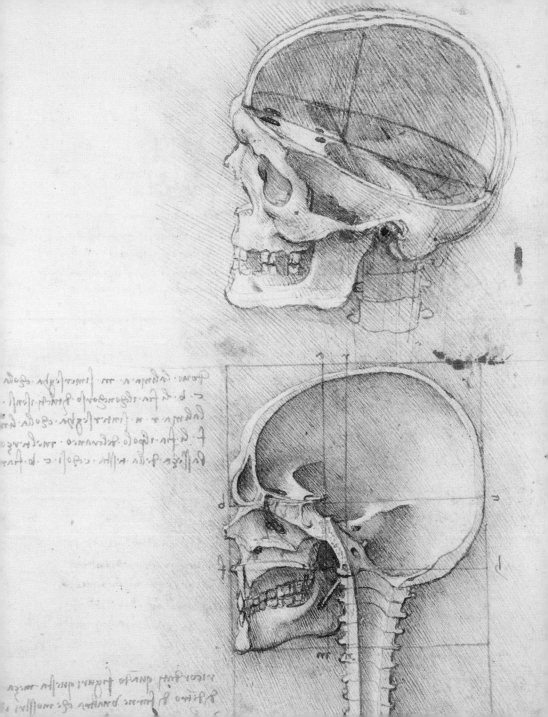

Ever since Freud, the topic of Leonardo's sexuality has fascinated scholars. In view of his explicit homosexuality in late adolescence, people have wondered about the possibility that he was bisexual or even had paedophile tendencies. In his drawings and writings, Leonardo often recognizes that the radical difference between human beings and animals lies in the ability to control one's instincts. Moreover, this famous drawing examines the physiology of copulation as a mechanical act, pure and simple, completely devoid of passion and feeling. No less famous are his negative comments on sexual intercourse, which he considered disgusting: 'The sexual act and the members employed therein are so repulsive that, if it were not for the beauty of the faces and the adornments of the actors and the pent-up impulse, nature would lose the human species.'

Diagram of copulation, lateral section (cat. 36)

LEONARDO MADE ACCURATE STUDIES INVOLVING THE SENSE OF SIGHT, repeatedly investigating the eyeball, the optic nerve and its connection to the brain. He wrote that 'since the eye is the window of the soul, the soul is ever in fear of losing it,' adding a series of remarks on the primacy of sight over the other senses, with a note of real anxiety at the thought of ever going blind. Leonardo had no scientific instruments for observing nature but used his own faculties and senses with extraordinary acuteness. He tested various systems for studying the eye, in particular the vitreous humour, such as boiling the eyeball to make it firm enough to dissect.

Anatomical study of the cerebral lobes and the scalp (cat. 37)

YEARS AFTER THE FIRST GROUP OF DRAWINGS done in Milan around 1490, Leonardo returned to studying human anatomy when he had the opportunity to conduct post-mortem research on cadavers at the hospital of Santa Maria Nuova in Florence. From Leonardo's notes, we may deduce that he performed at least fifteen complete autopsies himself, seeking innovative methods to preserve internal organs and depict them more accurately. For example, he made casts of the ventricles of the brain by injecting them with wax. This drawing is one of the most complete and impressive of the series, an obvious indication of a profound desire to know, with a capacity for continuous analytical observation, besides displaying extraordinary skill in draughtsmanship. The scientific 'certainty' obtained through direct, concrete experience is one of the clearest demonstrations of a typical Leonardesque concept: 'It seems to me that those sciences that are not born of experience, the mother of all certainty, are vain and full of errors and do not result in known experience. That is, their origin, or means, or ends do not pass through any of the five senses.'

View of the cardiovascular system and a woman's mammary and abdominal organs (cat. 42)

The great majority of Leonardo's anatomical drawings are in the British Royal Collection at Windsor, but there are important sheets in other libraries and drawing collections as well. The Schlossmuseum in Weimar possesses this extraordinary study of the brain, in which Leonardo 'takes apart' the skull as if it were a piece of equipment, clearly showing the steps of assembly. Examples like this increase our regret at his failure to complete the treatise on which he was already far advanced in the winter of 1510. Leonardo's anatomical drawings, so accurate and precise, remained unused, as if a comment on a well-known statement by their creator: 'That science is most useful whose fruit is most communicable, and conversely what is less communicable is less useful. The end result of painting is communicable to all the generations of the universe.'

p. 212

Leonardo made about 750 anatomical drawings, of differing degrees of completion and complexity. Various avenues of research can be identified: the analysis of the 'movements of the soul' and their origin; the study of the human body for the purpose of rendering it in painting; and a progressive investigation of life and physiology. Leonardo had an especially intense recollection of calmly conversing with an old man until shortly before he died, passing away without any pain: 'And this old man, a few hours before his death, told me he was over a hundred years old and felt nothing wrong with his body other than weakness; and sitting on a bed in the hospital of Santa Maria Nuova in Florence, with no other movement or sign of any mishap, he passed from this life. And I dissected him to see the cause of so gentle a death.'

Physiological presentation of the brain (cat. 43)
p. 212 *Anatomical studies of the rotation of the arm* (cat. 45)

p. 213

LEONARDO'S RESEARCH ON THE HUMAN BODY cannot be entirely dissociated from his activity as a painter. Although in early maturity, Leonardo drew the human body inscribed in a circle and a square, following the rules of the harmonic proportions of the so-called Vitruvian Man, with the practice of anatomical dissection his observations abandoned any pre-set framework. In Leonardo's view, 'better a small certainty than a big lie'. The purpose of this study of the musculoskeletal system and the joints also appears to have been to provide artists with a correct analysis of gestures and torsion.

WHEN LEONARDO RETURNED TO MILAN, he pursued his anatomical research with renewed enthusiasm in cooperation with Marcantonio della Torre, a medical doctor and philosopher who, after having been vice-rector of the Athenaeum in Padua, taught anatomy at the University of Pavia. It was a very promising collaboration, and Leonardo was confident that he would be able to complete his treatise focusing on the skeletal system and spinal column. Unfortunately, the untimely death of della Torre in a plague epidemic in 1511 put an end to this work. Leonardo would later complain of the difficulties he encountered in Rome, where his research at the hospital of Santo Spirito was regarded with suspicion and hindered by the authorities.

p. 213 *Anatomical studies of the muscles of the shoulder blade and of the mechanics of the stabilization of the joints of the clavicle* (cat. 46)
Anatomical studies of the musculature of the arm and shoulder (cat. 47)

Among the most impressive images of Leonardo's unfinished anatomy manual are those of the foetus in the mother's womb: here is the beginning of life. Studying the cadaver of a woman who died in childbirth and a foetus spontaneously aborted at seven months, Leonardo conducted pioneering research, with physiological intuitions well ahead of his time. For example, he correctly observed that the foetus, immersed in the amniotic fluid, does not breathe: 'If it were to breathe it would be drowned, and breathing is not necessary to it because it receives life and is nourished from the life and food of the mother.' Medical historians have noted that these drawings do not depict a human placenta, but that of a cow.

Anatomical study of a foetus in the womb (cat. 48)

THE THEME OF THE BIRTH OF LIFE is very prominent in the research of Leonardo, who felt that 'you must represent all the stages of the limbs, from man's creation to his death'. These drawings investigate the development of the baby in its mother's womb, observing both the position of the foetus and the changes in female physiology during pregnancy.

From Leonardo's manuscripts, we can deduce that he performed an autopsy on an aborted foetus and a woman who died in pregnancy. However, he combined his observations on human embryology with information derived from dissecting other mammals.

Studies of the foetus in the womb and of the dimensions
and structure of the female reproductive organs (cat. 49)

DEALING WITH THE NECK MUSCLES IN RELATION TO THE MUSCLES, tendons and bones of the trunk, this is one of Leonardo's last drawings of the human body in preparation for a treatise that never reached completion. The immediate impact of the energetic chiaroscuro and strong visual effect notwithstanding, scholars have noted some inaccuracies, which they attribute to the artist's advanced age. Some date the sheet to the period of the controversial anatomy studies carried out at the hospital of Santo Spirito in Rome, but it could even date from after the move to France. Still, rather than a weakening of Leonardo's hand, we might consider this an unexpected development in his research. Perhaps instead of concentrating on analytical observation and the graphic reproduction of the anatomy, the artist was looking for a structural and visual analogy between the spinal column and the main mast of a ship, with tendons arranged like rigging: 'Such a gathering of muscles to the spine holds it upright, just as the ropes of a ship support its mast; and the same ropes, attached to the mast, also partly support the sides of the ships to which they are attached.' Leonardo had a predilection for this kind of analogy, like the well-known similarities he found between eddying water and a little girl's wavy hair, or water running along the ground and the human circulatory system.

Anatomical studies of the neck and shoulder muscles (cat. 50)

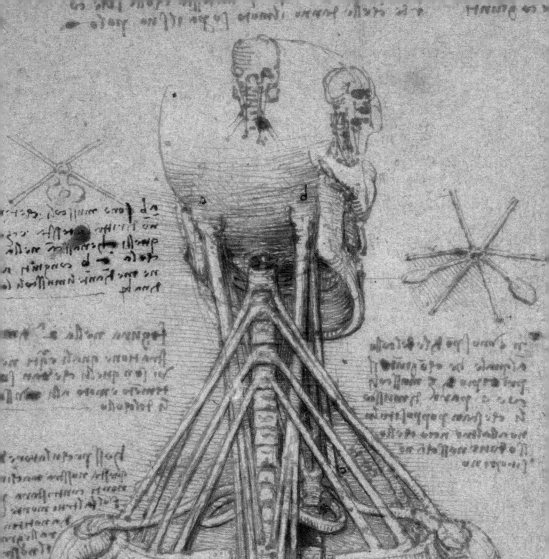

Reading List

D. A. Brown. *Leonardo da Vinci: Origins of a Genius*. New Haven, 1998.

W. Isaacson. *Leonardo da Vinci*. New York, 2017.

M. Kemp. *Leonardo on Painting*. New Haven, 2001.

−. *Leonardo*. Oxford, 2004.

Leonardo da Vinci: The Codex Leicester, exhibition catalogue. Florence: Galleria degli Uffizi, 2018.

Leonardo da Vinci. Il disegno del mondo, exhibition catalogue. Milan: Palazzo Reale, 2015.

Leonardo da Vinci: Master Draftsman, exhibition catalogue. New York: Metropolitan Museum of Art, 2003.

P. C. Marani, ed. *Leonardo. Dagli studi di proporzioni al Trattato della Pittura*, exhibition catalogue. Milan, 2007.

P. C. Marani and P. Brambilla Barcilon. *Leonardo, 'The Last Supper'*. Chicago, 2001.

R. Nanni. *Leonardo and the 'Artes Mechanicae'*. Milan, 2014.

J. Nathan and F. Zöllner. *Leonardo da Vinci: The Complete Paintings and Drawings*. Cologne, 2003.

C. Pedretti. *Leonardo & io*. Milan, 2008.

−. *Leonardo: The Art of Drawing*. Florence, 2014.

C. Pedretti, P. Galluzzi and D. Laurenza. *Leonardo*. Florence, 2017.

D. Sguaitamatti. *'The Last Supper', Leonardo da Vinci: The Masterpiece Revealed through High Technology*. Novara, 2012.

L. Syson, ed. *Leonardo da Vinci: Painter at the Court of Milan*, exhibition catalogue. London: National Gallery, 2011.

−, ed. *Leonardo da Vinci. Scritti scelti. Frammenti letterari e filosofici*. Florence, 2006.

M. Taddei, E. Zanon and D. Laurenza. *Le macchine di Leonardo*. Florence, 2017.

E. Villata. *Leonardo da Vinci*. Milan, 2005.

Photographic Credits

Florence, Scala: cat. 8, cat. 11, cat. 12, cat. 30, pp. 54–55, 71, 90–91, 92–93, 136, 146, 164; Courtesy of the Ministero Beni e Att. Culturali e del Turismo: cover, cat. 2, cat. 3, cat. 14, cat. 20, cat. 23, cat. 24, pp. 86–87, 94–95, 96–97, 99, 110, 112, 115, 116–117, 126–127, 141, 160, 168–169; De Agostini Picture Library: cat. 16, cat. 33, pp. 82, 129, 130–131; Salvator Mundi LLC / Art Resource, New York: cat. 21, pp. 102, 105, 157; The National Gallery, London: cat. 17, pp. 76–77, 154, 172–173

Florence, Studio Fotografico Paolo Tosi: cat. 9, pp. 50, 53, 64, 68–69

Kraków, National Museum © Laboratory Stock: cat. 13, pp. 56–57, 149, 166

London, Royal Collection Trust © Her Majesty Queen Elizabeth II, 2018 / Bridgeman Images: cat. 34, cat. 35, cat. 36, cat. 37, cat. 42, cat. 45, cat. 46, cat. 47, cat. 48, cat. 49, cat. 50, cat. 51, pp. 48, 200–201, 203, 205, 206, 209, 212, 213, 214, 216, 219, 221

Milan, Veneranda Biblioteca Ambrosiana / Metis e Mida Informatica / Mondadori Portfolio: cat. 25, cat. 26, cat. 27, cat. 28, cat. 29, cat. 31, cat. 32, cat. 38, cat. 39, cat. 40, cat. 41, pp. 182, 184, 185, 186, 187, 188, 189, 191, 192, 194–195, 196

Paris, RMN-Grand Palais (musée du Louvre) / Daniel Arnaudet / Jean Schormans: cat. 10, pp. 124–125; Lewandowski / Le Mage / Gattelet: pp. 100–101, René-Gabriel Ojéda: cat. 19, pp. 58–59, 79, 132–133, 174, 177; Franck Raux: pp. 72–73, 75, 89; Tony Querrec: cat. 7, cat. 22, pp. 106, 122–123, 162–163, 178–179; Michel Urtado: cat. 15, cat. 18, pp. 150–151, 152–153, 169

Spardorf, Bayer & Mitko – Artothek: cat. 6, pp. 66, 145

Venice, Gallerie dell'Accademia / Bridgeman Images: cat. 44, p. 62

Washington, National Gallery of Art: cat. 1, cat. 4, cat. 5, pp. 85, 118, 120–121, 138, 142

Weimar, Klassik Stiftung Weimar, Bestand Museen: cat. 43, p. 210

Colophon

TEXT
Stefano Zuffi

TRANSLATION
Donald Pistolesi

EDITING
First Edition Translations Ltd, Cambridge, UK

PICTURE RESEARCH
Sophie Suykens

COORDINATION
Ruth Ruyffelaere

GRAPHIC DESIGN & TYPESETTING
Paul Boudens, Dylan Van Elewyck

PRODUCTION
Emiel Godefroit

PRINTING
DZS Grafik

Cover: *Baptism of Christ* (cat. 2, detail)

© 2019 Ludion & Stefano Zuffi

ISBN (EUROPE) 978-94-9303-907-0
D/2019/6328/4

ISBN (US) 978-1-4197-4061-9
Distributed in the US by Abrams, an imprint of ABRAMS.

Published by Ludion.

Ludion
Leguit 23
2000, Antwerp, Belgium
info@ludion.be

WWW.LUDION.BE